new terrace design

daab

Alberto Burckhardt | Pierino Residence 8

Alberto Martínez Carabajal | Girona House 16

Aleks Istanbullu Architects | Hinge House 20

Álvaro Siza | Céramique Penthouse 24

Anne Marie Sumner | Felix Beach House 28

Claudi Aguiló, Xavier Vendrell Sala | Abelló Residence 36

Culti | La Sommità 40

Delugan Meissl Associated Architects | Ray 1 House 44

Eduardo Souto de Moura | Rua do Crasto House 52

Emili Fox | House in Mosman 56

Farnan Findlay Architects | Port Fairy House 62

Federico Delrosso | Lessona Terrace 66

Felipe Pich-Aguilera, Teresa Batlle | Arquerons House 72

Graftworks Architecture + Design | Greenwich Roof Garden 76

Jaime Guzmán, Fernando Ogarrio | Borja Residence 84

Jaime Sanahuja | Toran House 88

Katerina Tsigarida Architects | Holiday House 94

Lazzarini Pickering | Positano Villa 98

London Town PLC | The Bridge 106

Magín Ruiz de Albornoz | Beach Condos 110

Magín Ruiz de Albornoz | Bétera House 116

MAP Arquitectos/Josep Lluís Mateo | Summer House 120

Marcio Kogan Architects | BR House 124

Marcio Kogan Architects | D'Andrea Henkin House 130

Marcio Kogan Architects | Quinta House 134

Prima Design | Portman Residence 140

Reinach Mendonça Arquitetos Associados | Glass House 144

Ricardo Legorreta | Lourdes Residence 148

Riegler Riewe | Penthouse T 154

Rios Clementi Hale Studios | Brentwood Pool & Terrace 158

Safdie Rabines Architects | Treehouse 162

Studio Architetti Associati di Andrea Lenzi e Stefano Bernardi | San Giuliano Mare Residence 166

StudioMAS/Pierre Swanepoel | Westcliff Estate 170

Thornsett Group | Marjory Street Terrace 178

Wolfgang Ritsch | Abrederis Residence 182

Como filtro que unifica suavemente exterior e interior, la terraza se ha convertido en una de las estancias complementarias más importantes de la casa contemporánea. Ya sean en voladizo, abiertas o techadas, como generosas extensiones de la planta baja o jardines colgantes en edificios residenciales, las terrazas permiten aumentar la sensación de amplitud al apropiarse de un fragmento del exterior. Este libro recoge una muestra de las múltiples posibilidades que presenta el diseño de estos espacios privilegiados, que constituyen un lugar social, de ocio y contemplación que mejora ostensiblemente la calidad de vida del hogar.

Comme un filtre qui rejoint aisément l'intérieur et l'extérieur, les terrasses sont devenues un des espaces complémentaires les plus importants dans la maison actuelle. Soit en aérée, ouvertes ou couvertes, comme une extension du rez-de-chaussée ou bien comme des jardins sur le toit des bâtiments résidentiels, les terrasses maximisent le sens d'espace en saisissant partiellement des aires extérieurs. Ce livre est un recueil des multiples possibilités que présente le dessin de ces espaces privilégiés: un endroit social, contemplatif et de loisir qui porte dans chaque maison une meilleure qualité de vie.

Come un filtro che congiunge dolcemente esterni e interni, la terrazza è diventata una delle abitazioni accessorie più importanti della casa moderna. Siano esse a sbalzo, aperte o chiuse, espansioni del piano terra o giardini pensili in edifici residenziali, le terrazze consentono di aumentare la sensazione di spaziosità poiché si appropriano di un frammento di spazio esterno. Questo libro presenta una selezione delle molteplici possibilità che offre il disegno di questi spazi privilegiati, che sono un luogo di ritrovo sociale, di ozio e di contemplazione che migliora notevolmente la qualità della vita in casa.

Wie ein Filter, der Innen und Außen miteinander verbindet, haben sich Terrassen zu einem der wichtigsten zusätzlichen Räume im modernen Haus entwickelt. Ob freitragend, geöffnet oder bedeckt, als Verlängerungen des Erdgeschosses, oder auch als Dachgärten in Mehrfamilienwohnungen; Terrassen vergrößern das Raumgefühl, indem sie sich einen Teil des Außenbereiches zu Eigen machen. Dieses Buch vermittelt Beispiele dieser privilegierten Bereiche, die als soziale-, unterhaltsame und beschauliche Orte die Lebensqualität erheblich verbessern.

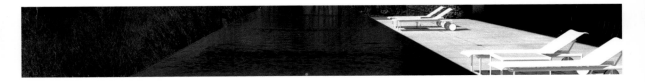

As a filter that smoothly merges interior and exterior, terraces have become one of the most important complementary spaces in today's contemporary house. Whether cantilevered, open or covered, as a wide extension of the ground floor or as roof gardens in residential buildings, terraces maximise the sense of space by partially seizing outdoor areas. This book is a showcase of the multiple design possibilities offered by these privileged spaces; an entertaining, social and contemplative place that improves the quality of life in every home.

Alberto Burckhardt | Bogotá, Colombia
Pierino Residence
Baru Islands, Colombia | 2004

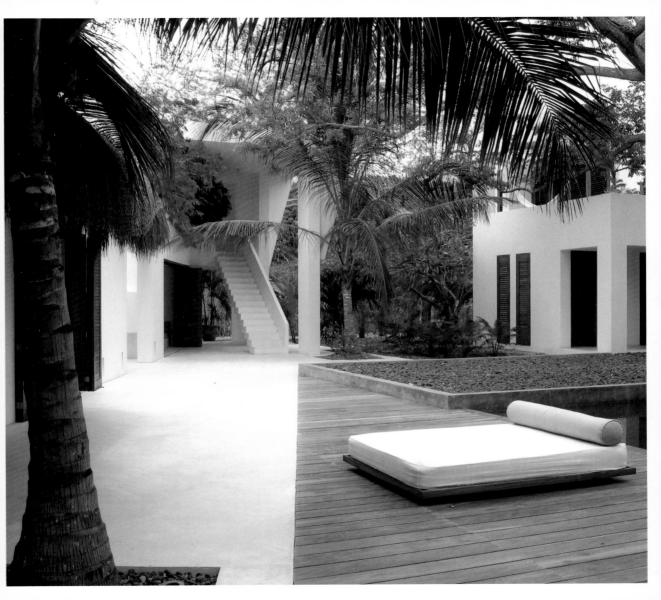

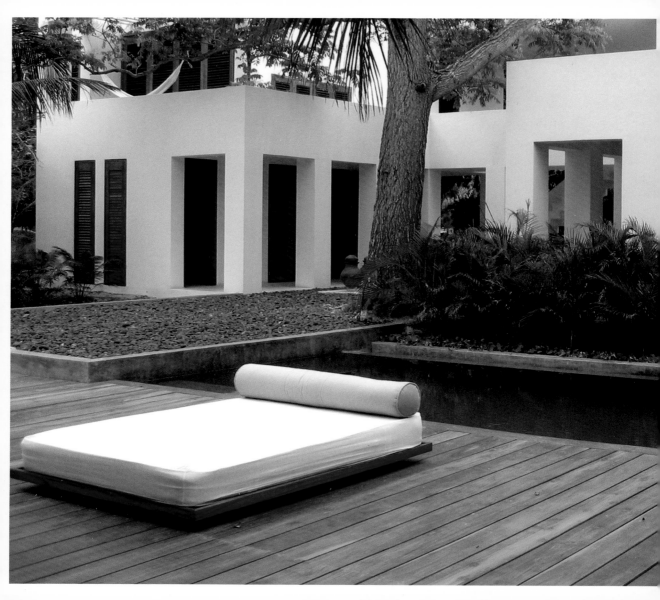

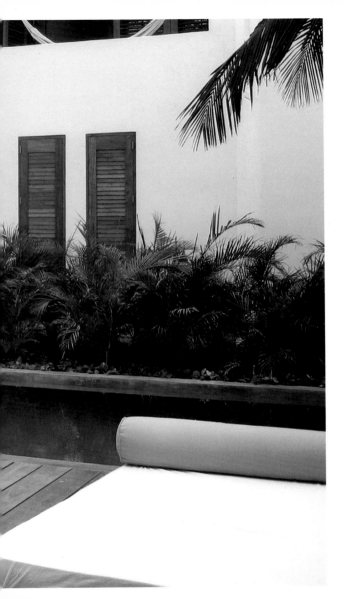

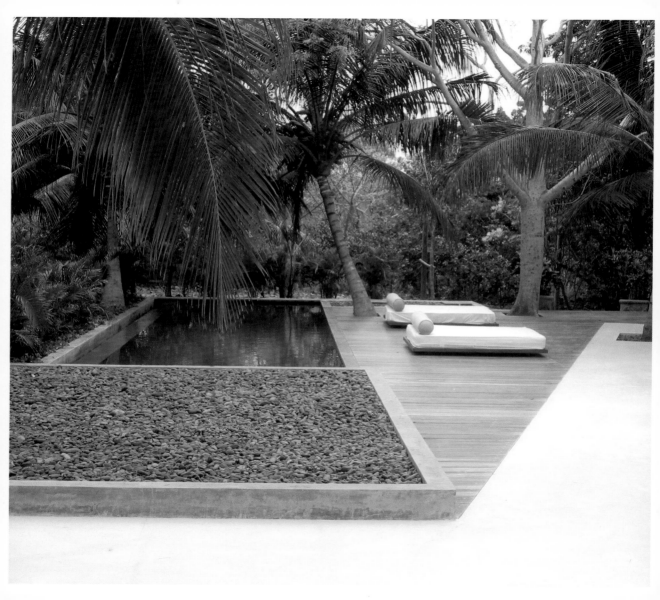

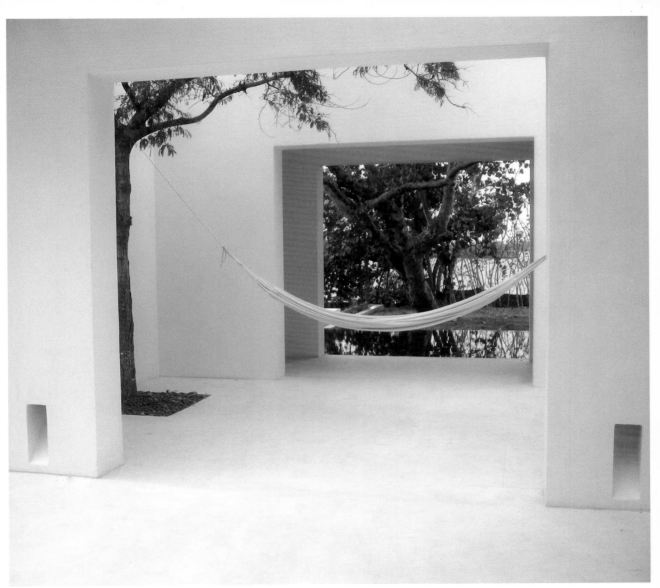

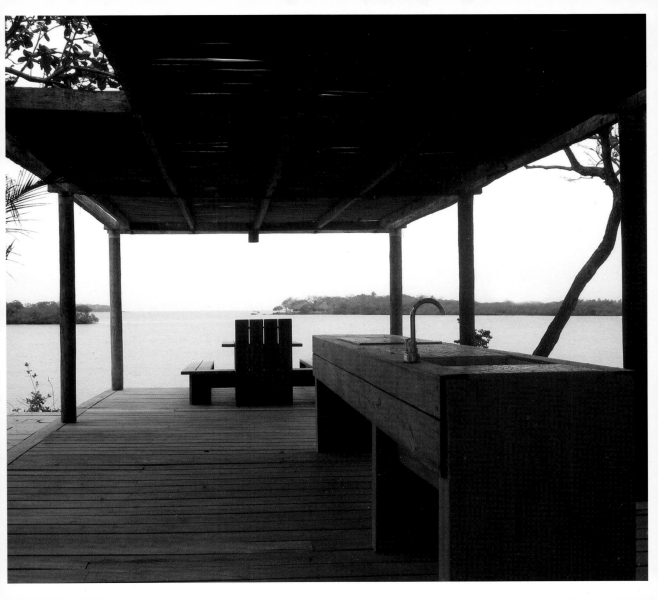

Alberto Martínez Carabajal | Barcelona, Spain
Girona House
Sitges, Spain | 2001

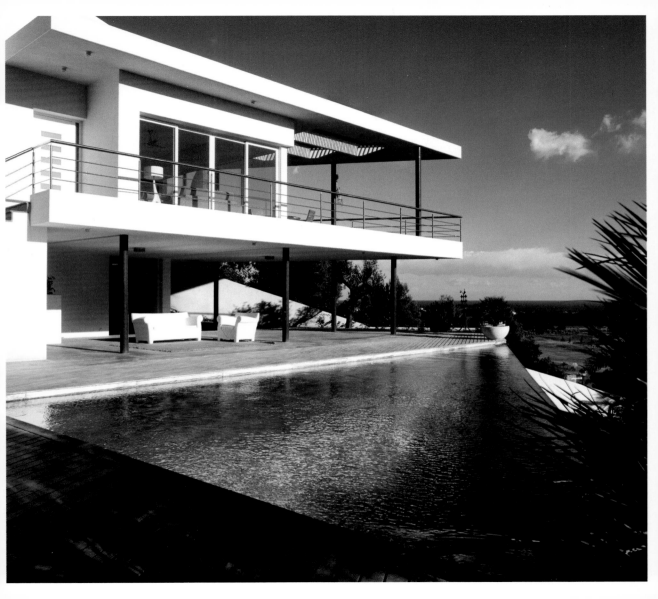

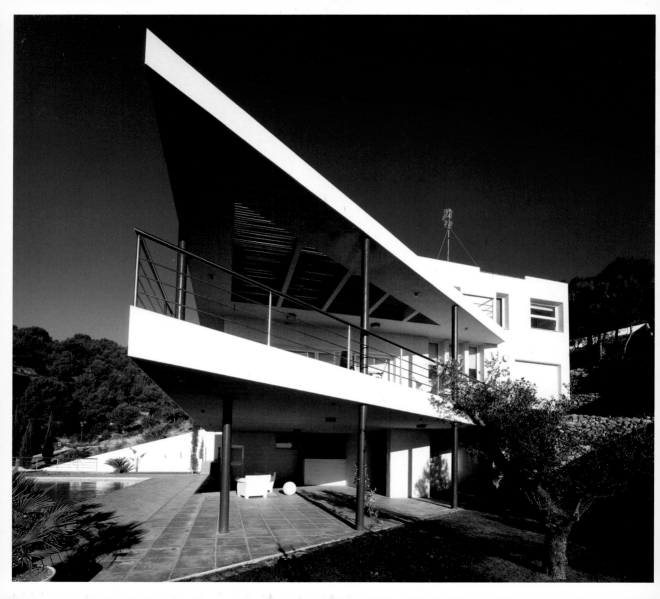

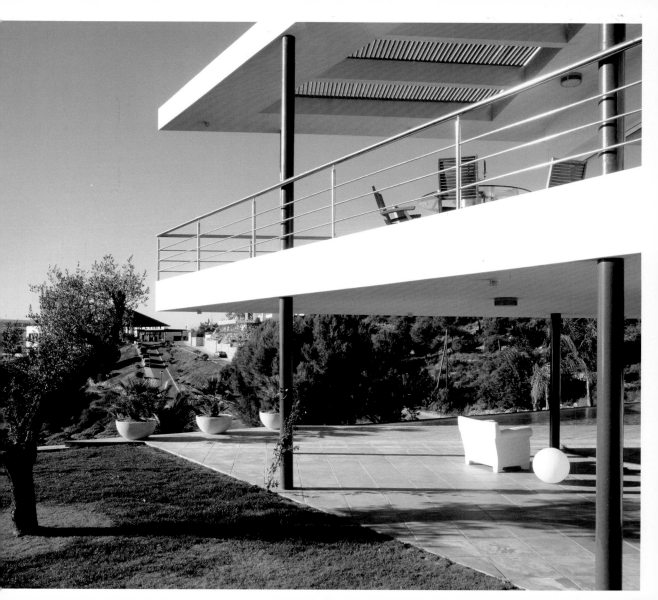

Aleks Istanbullu Architects | Santa Monica, California, USA
Hinge House
Los Angeles, California, USA | 2003

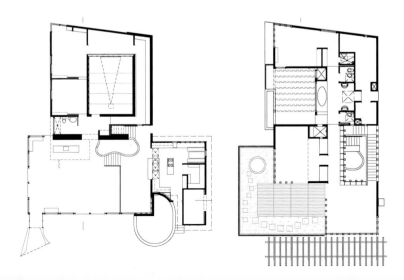

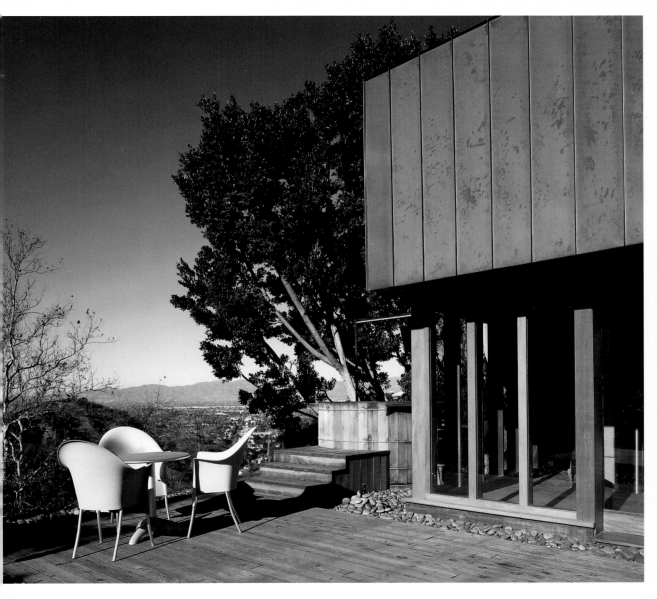

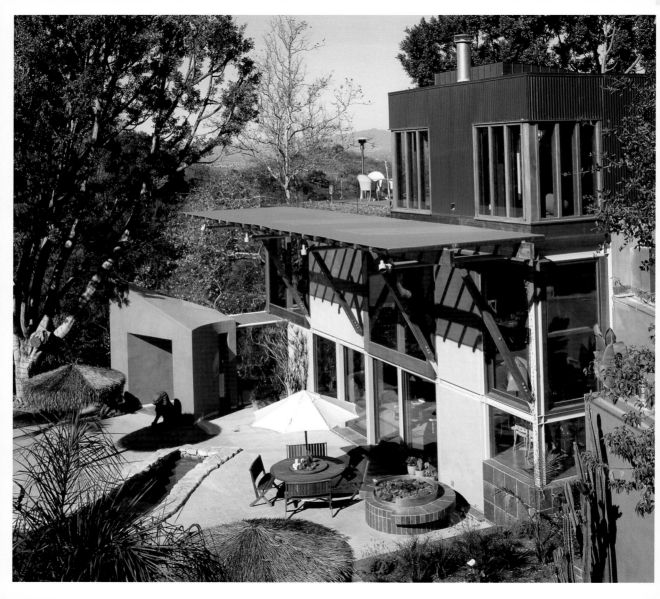

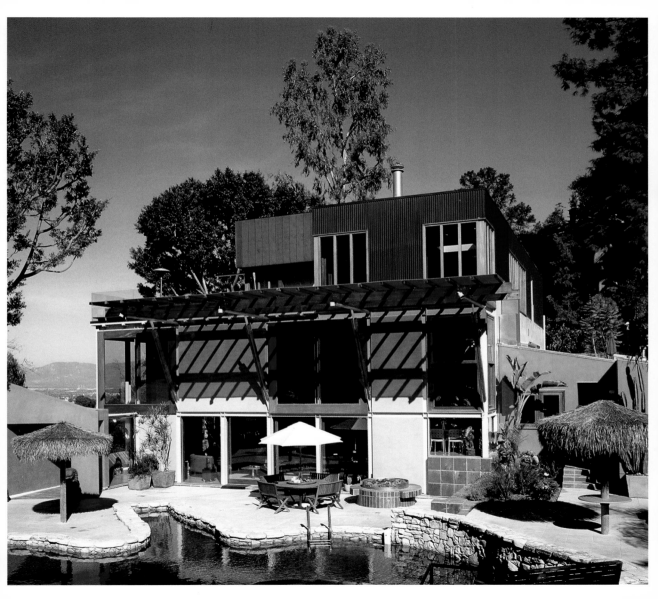

Álvaro Siza | Porto, Portugal
Céramique Penthouse
Maastricht, Netherlands | 2001

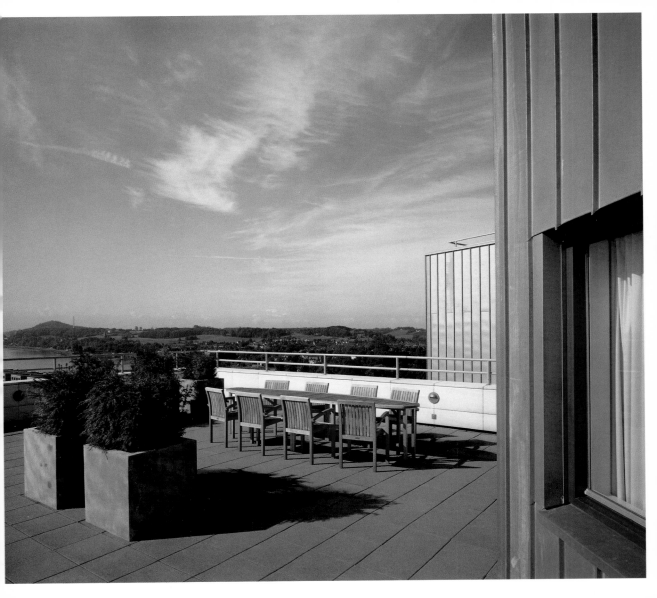

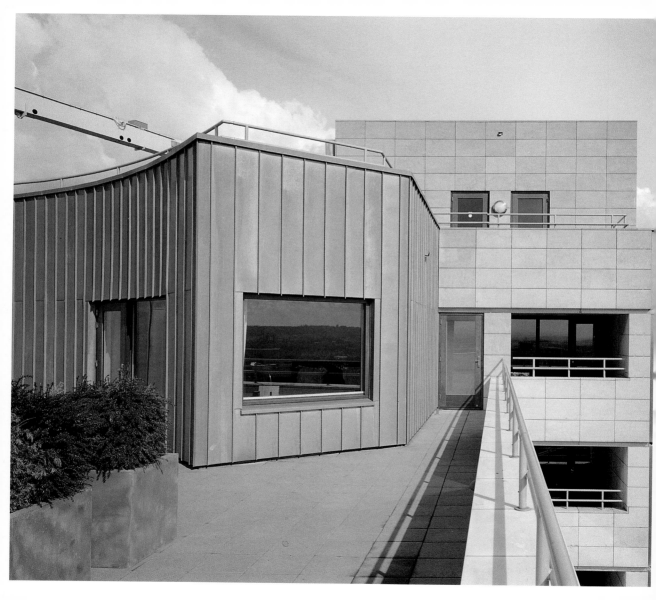

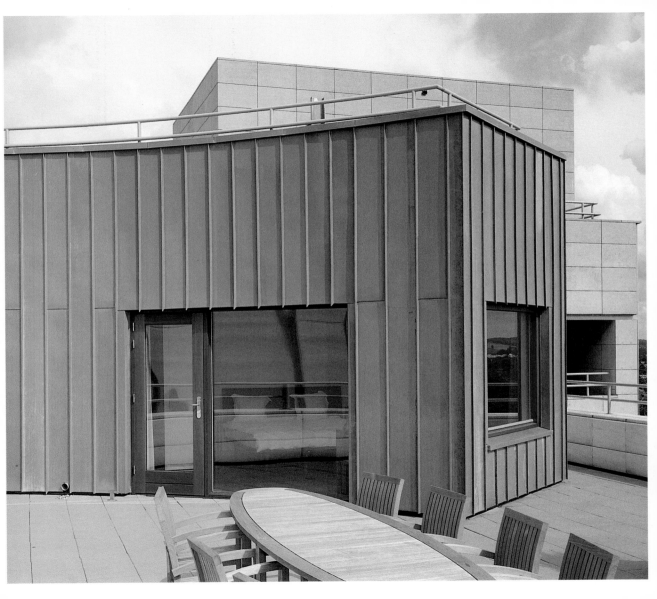

Anne Marie Sumner | São Paulo, Brazil
Felix Beach House
Ubatuba, Brazil | 1998

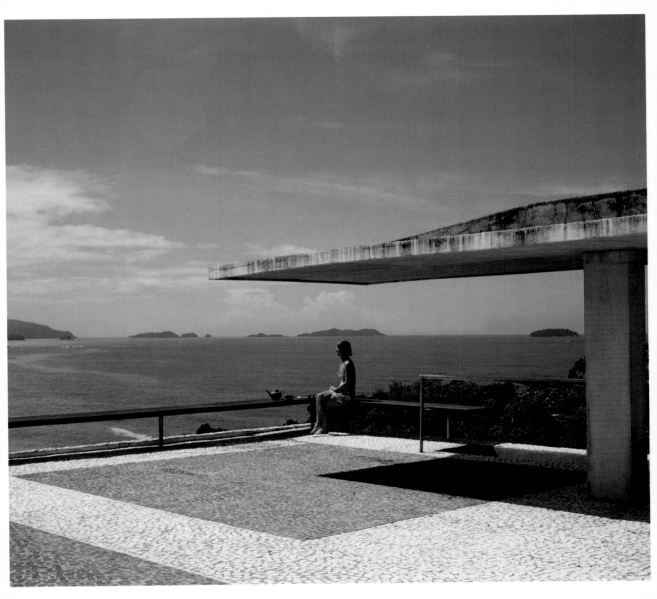

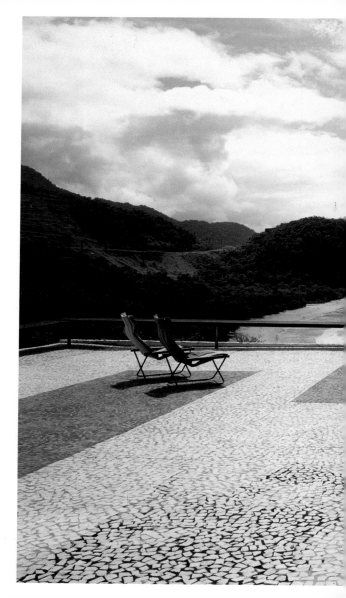

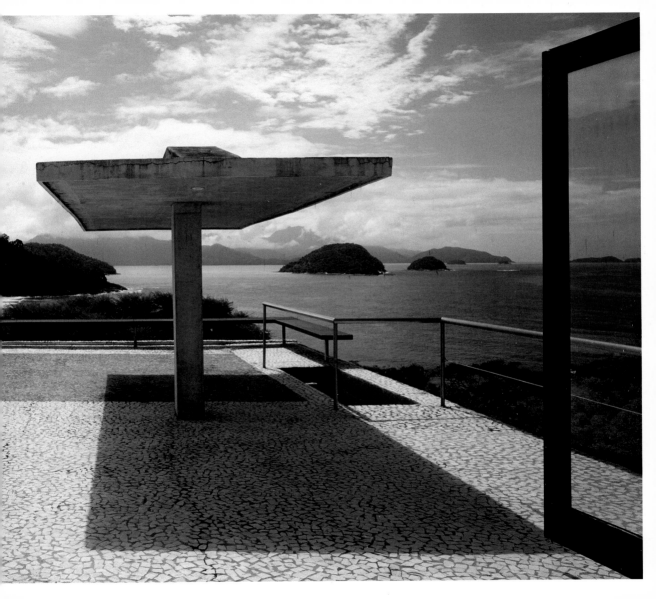

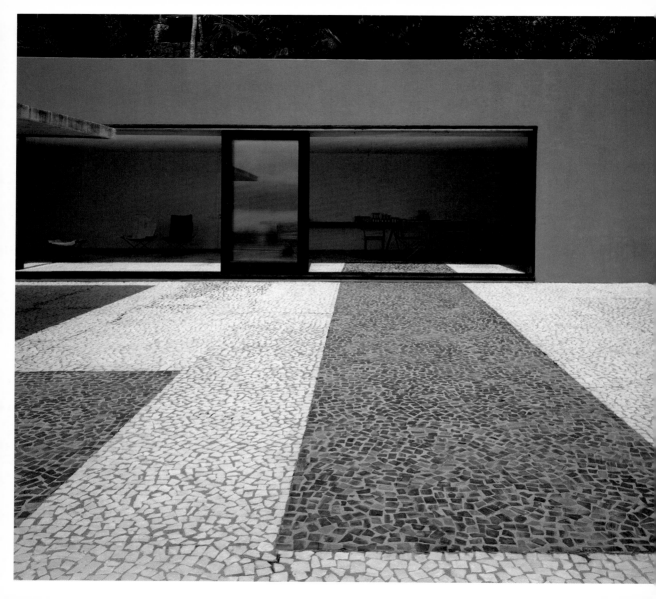

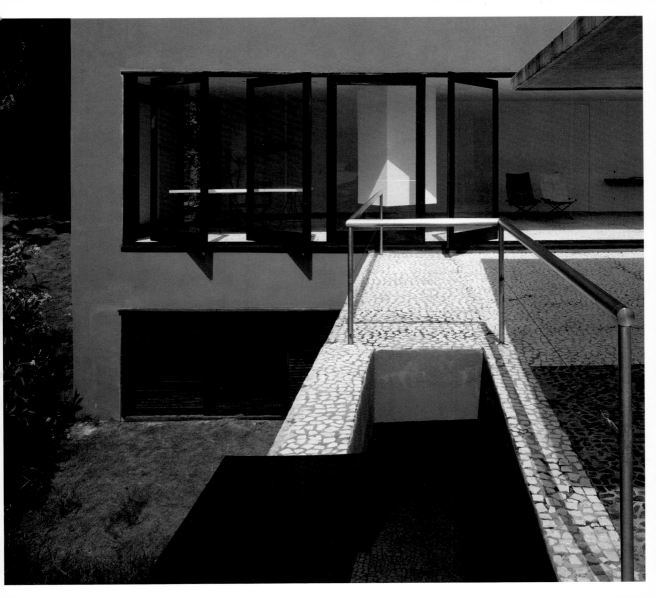

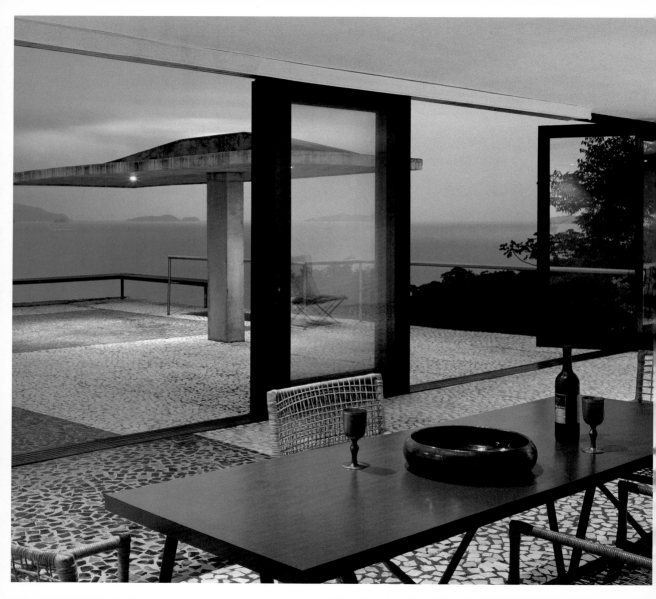

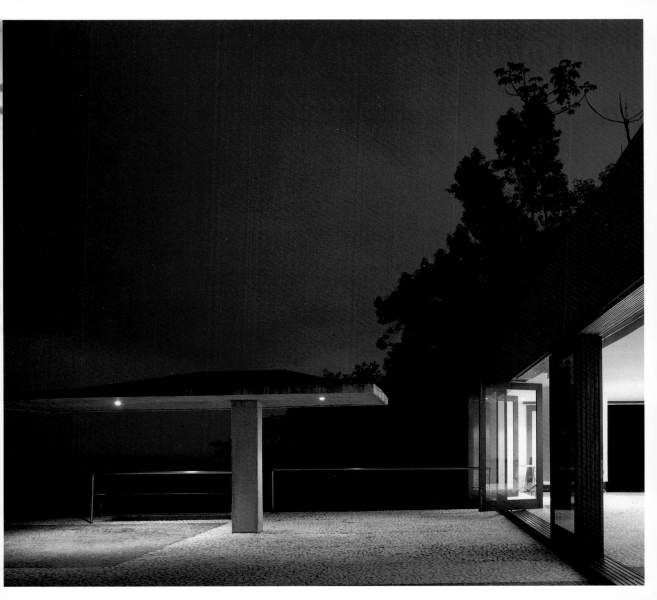

Claudi Aguiló, Xavier Vendrell Sala | Barcelona, Spain
Abelló Residence
Tarragona, Spain | 2004

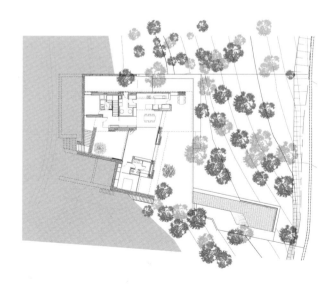

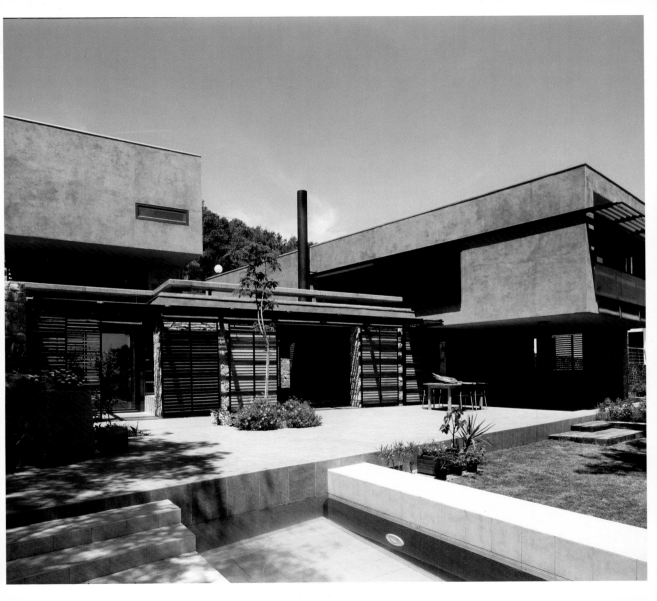

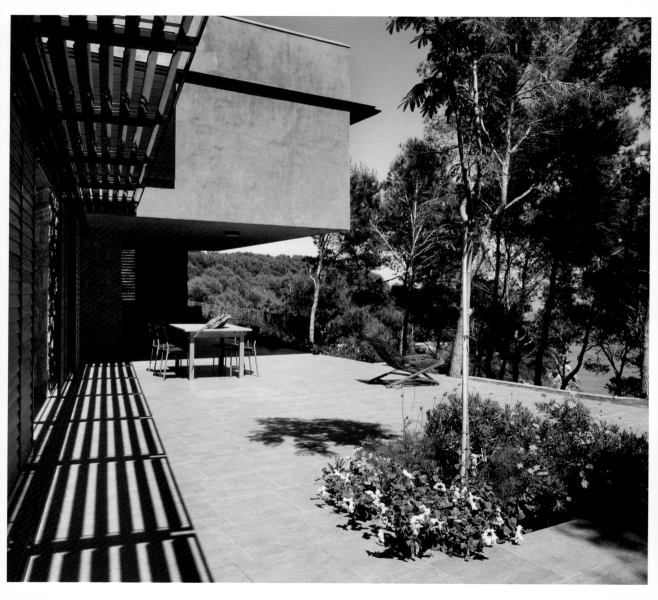

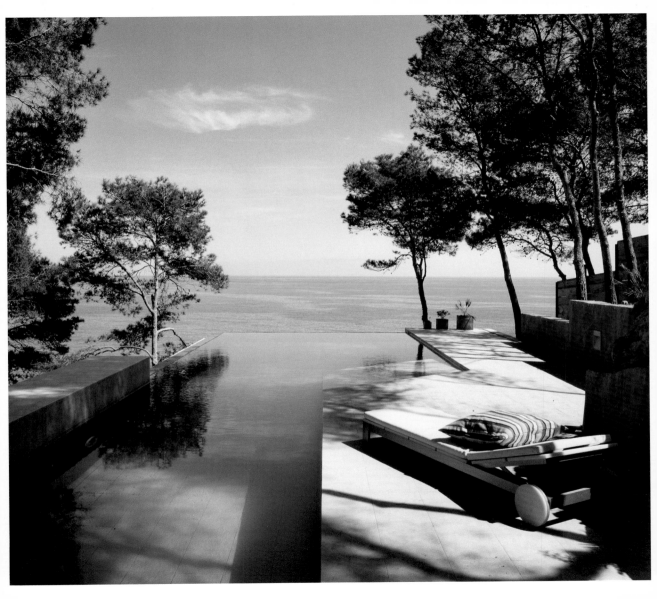

Culti | Milan, Italy
La Sommità
Ostuni, Italy | 2004

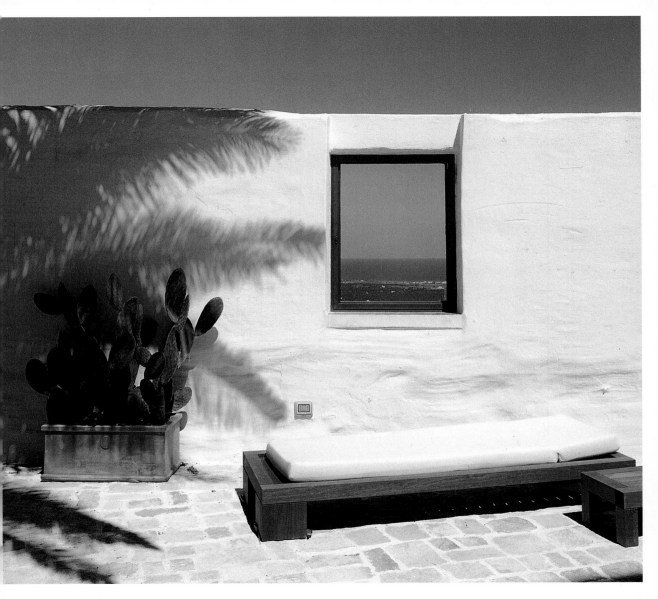

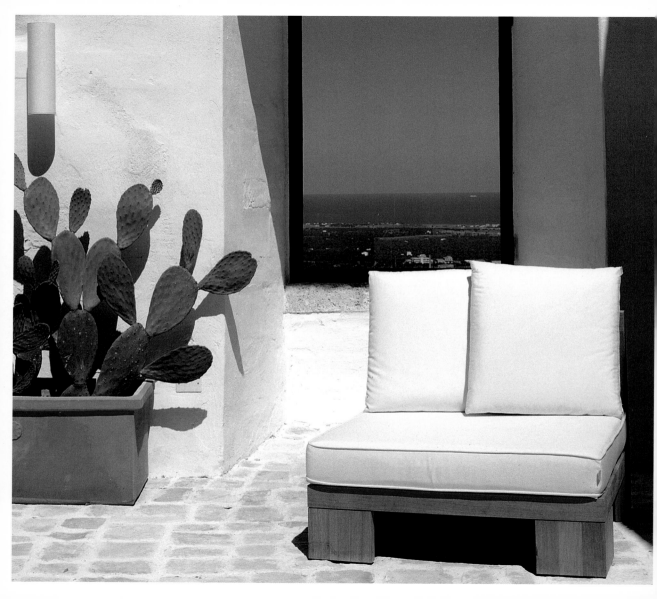

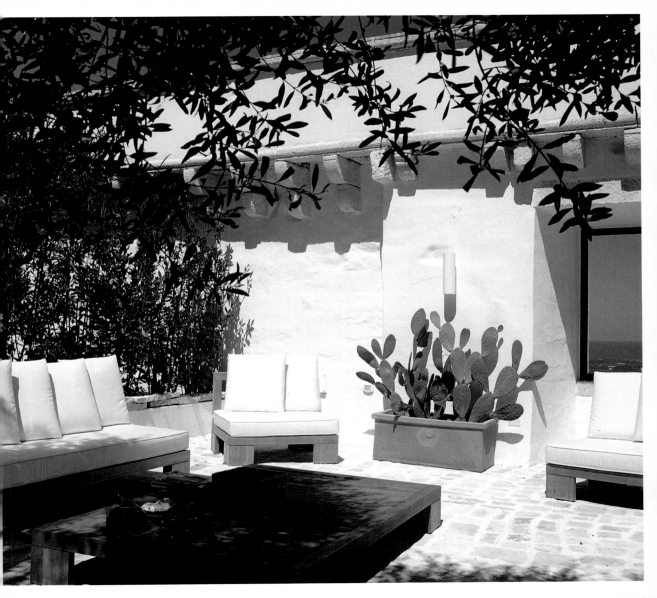

Delugan Meissl Associated Architects | Vienna, Austria
Ray 1 House
Vienna, Austria | 2003

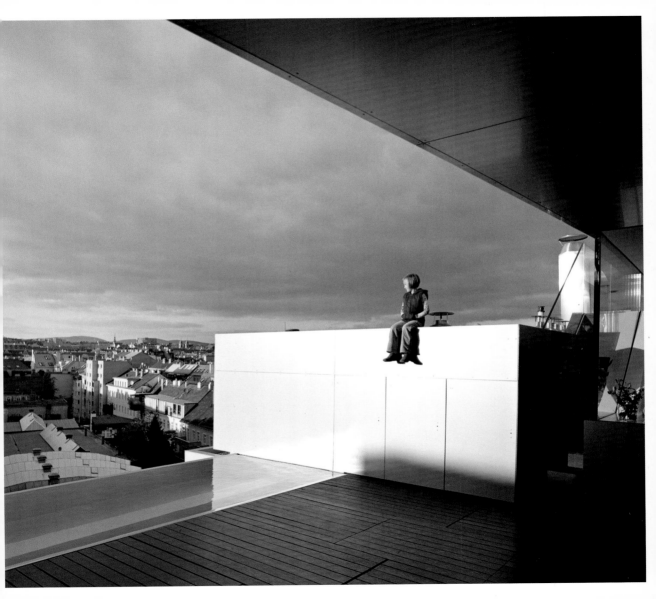

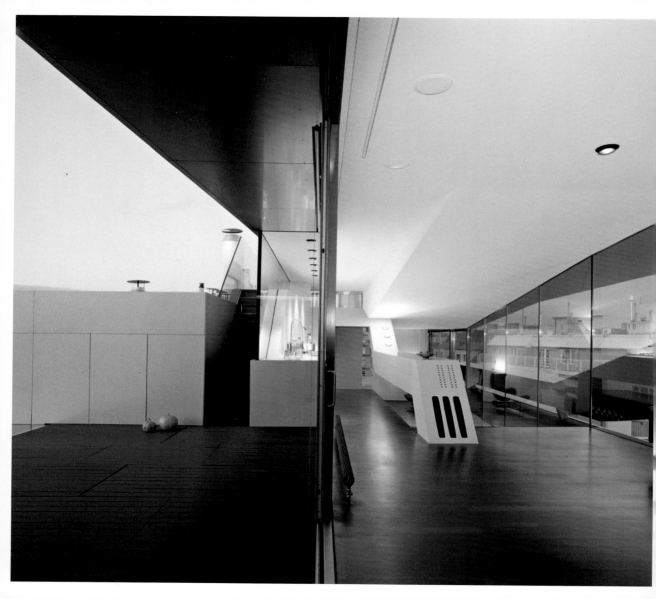

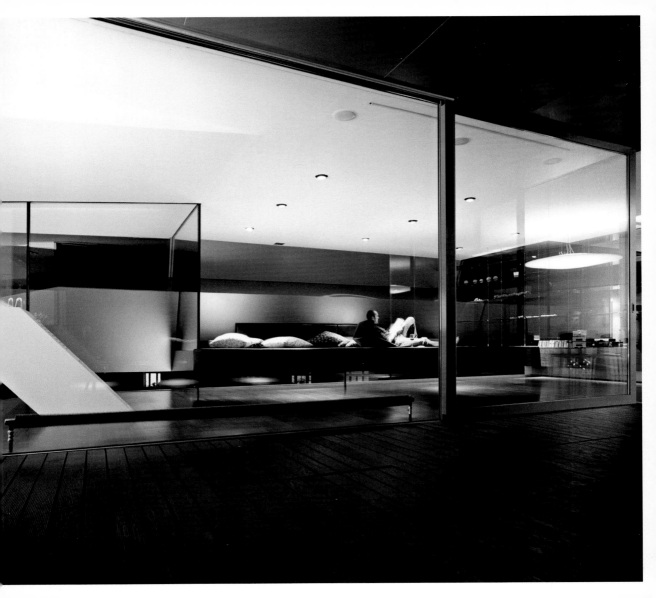

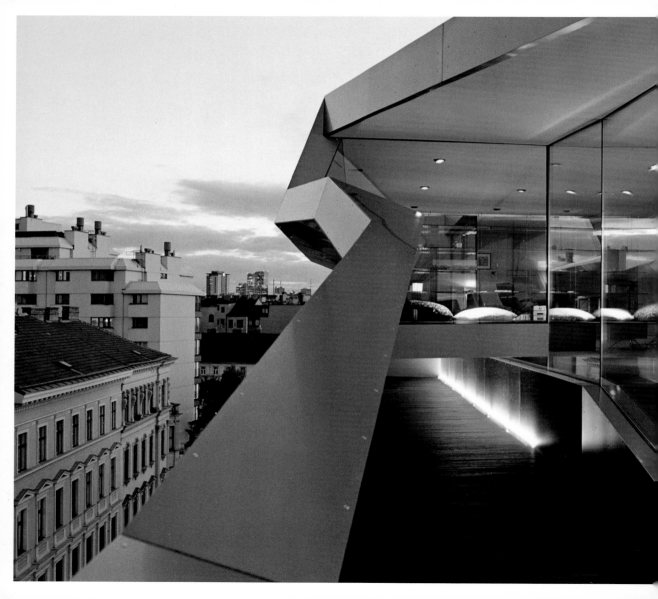

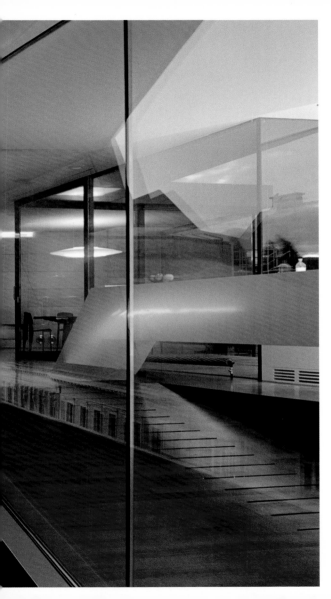

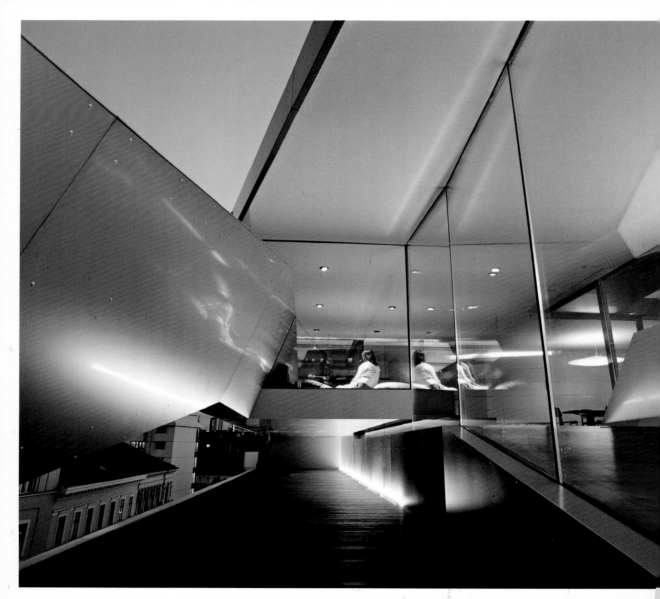

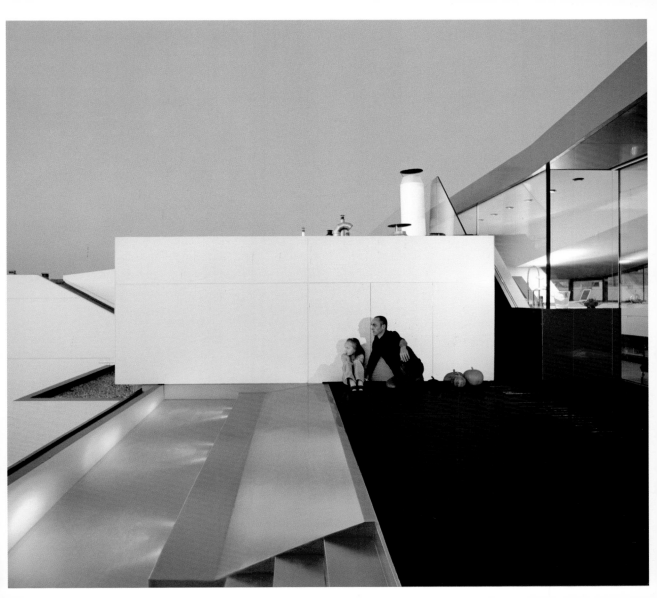

Eduardo Souto de Moura | Porto, Portugal
Rua do Crasto House
Porto, Portugal | 2001

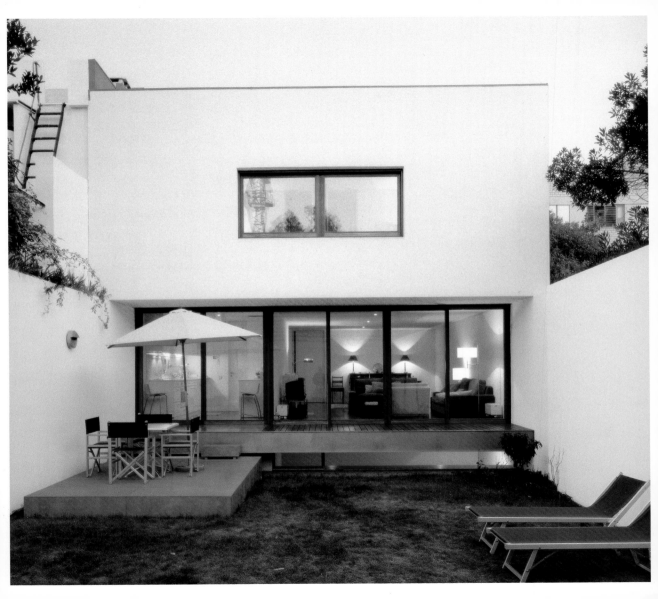

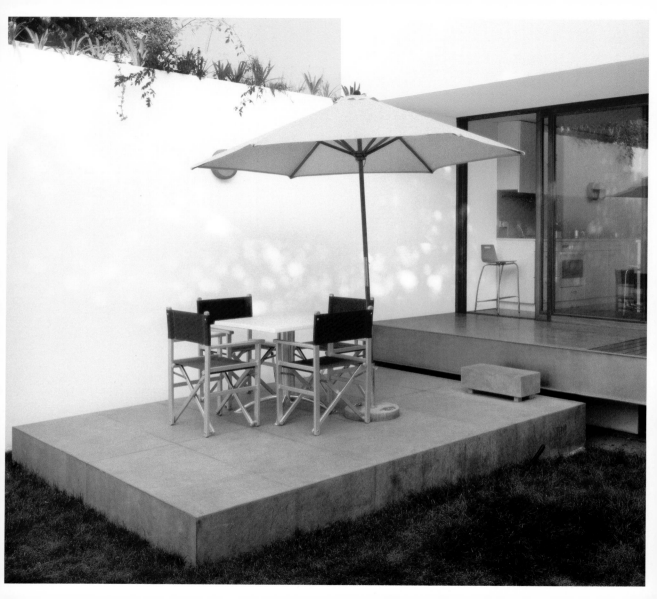

Emili Fox | Sydney, Australia
House in Mosman
Sydney, Australia | 2001

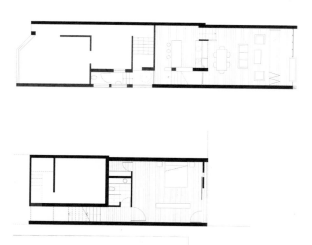

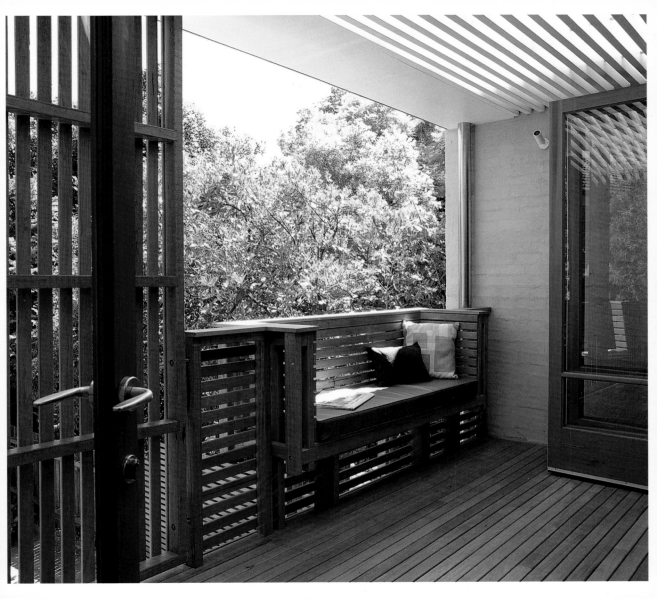

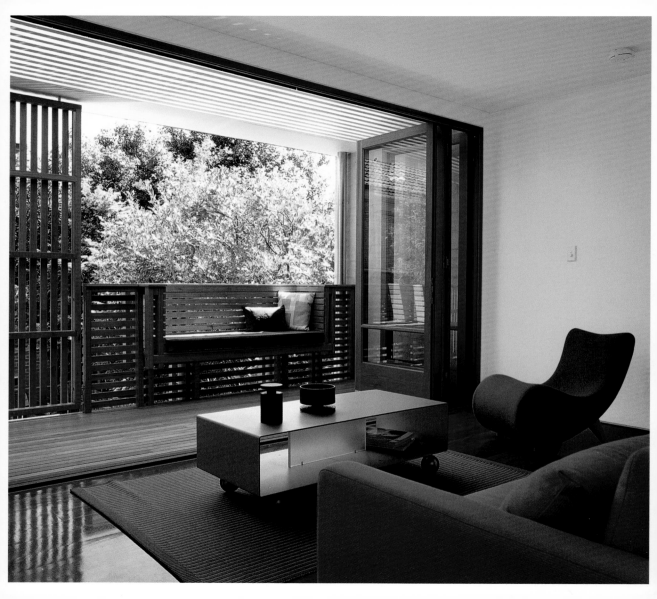

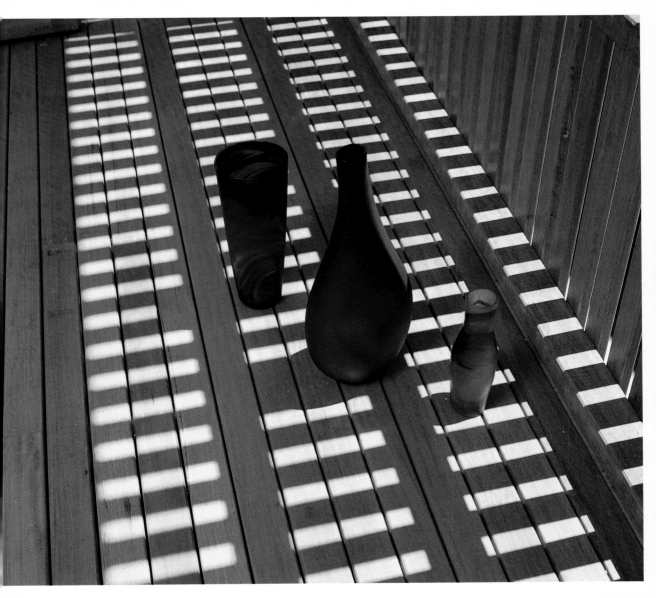

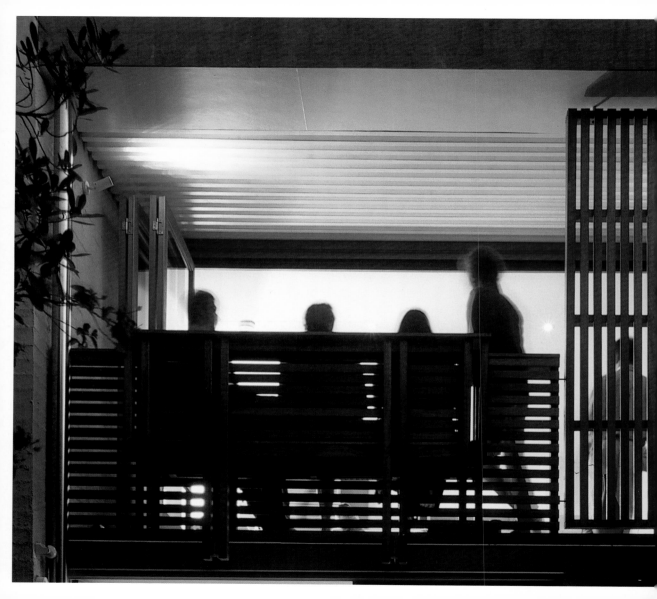

Farnan Findlay Architects | Sydney, Australia
Port Fairy House
Victoria, Australia | 2003

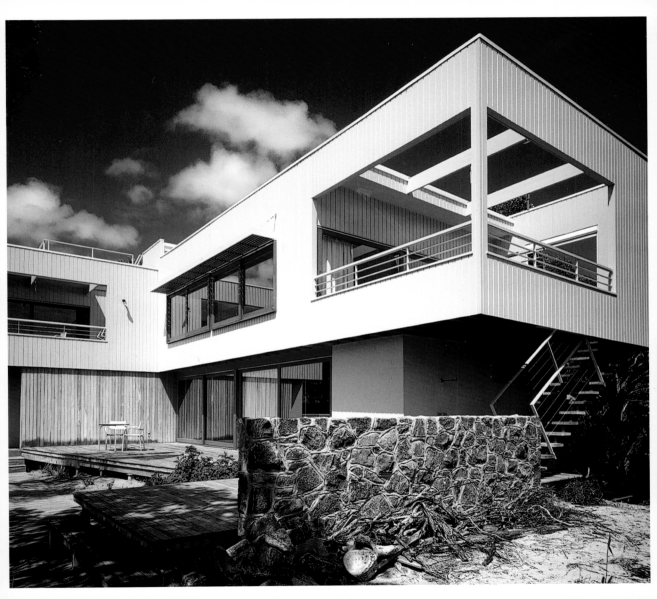

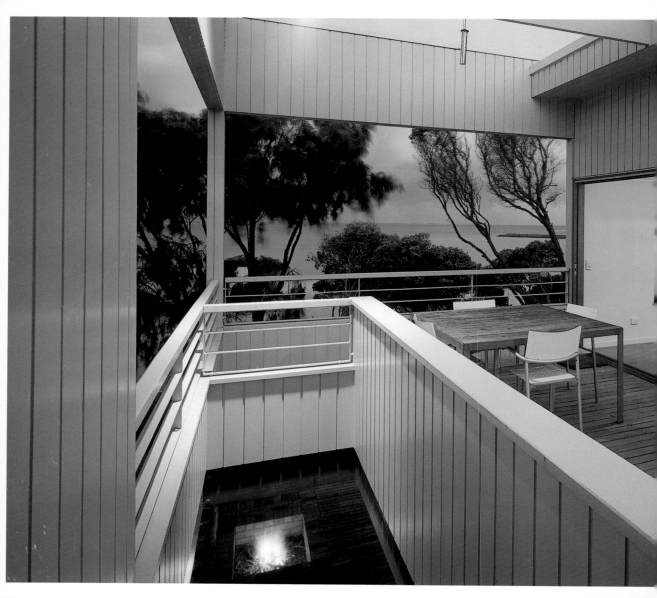

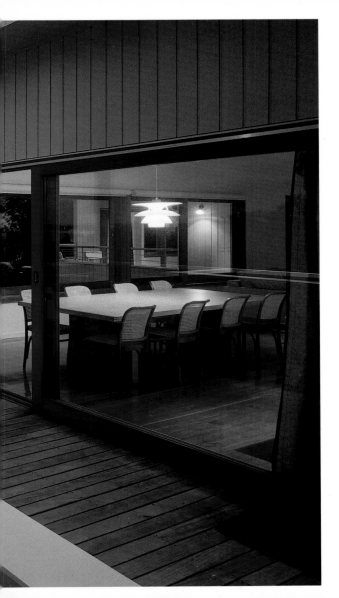

Federico Delrosso | Biella, Italy
Lessona Terrace
Biella, Italy | 2002

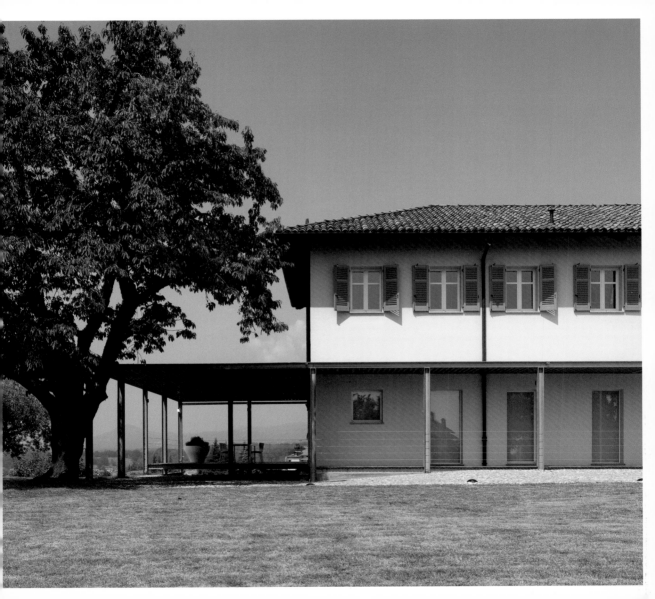

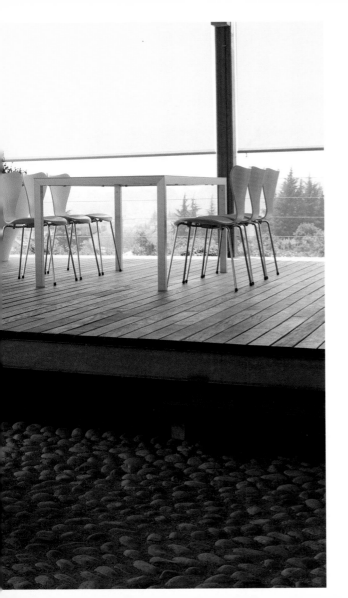

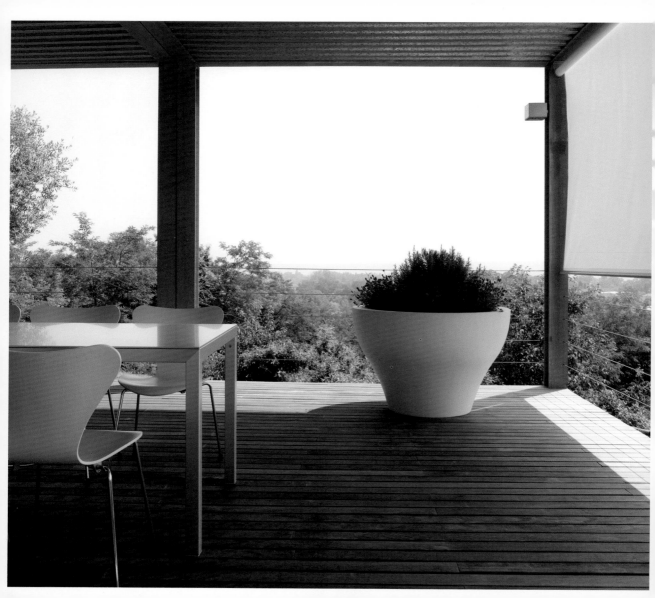

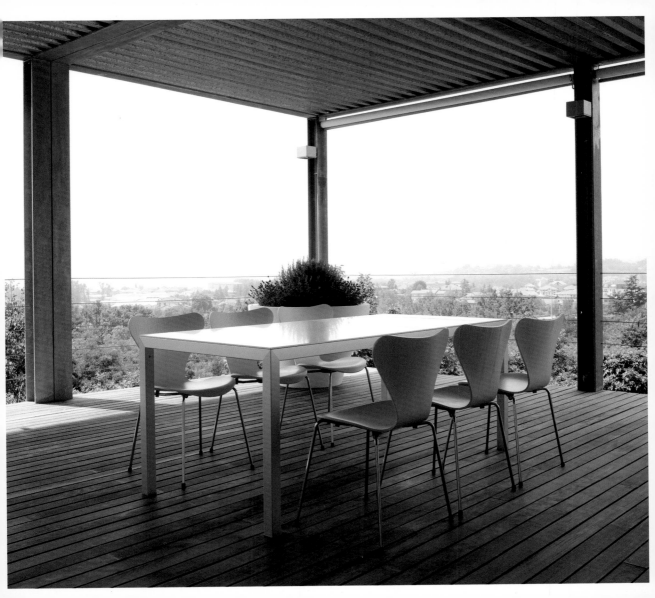

Felipe Pich-Aguilera, Teresa Batlle | Barcelona, Spain

Arquerons House
Sant Andreu de Llavaneres, Spain | 2004

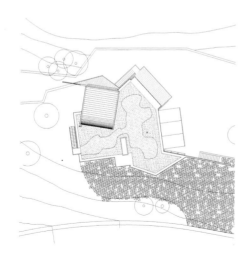

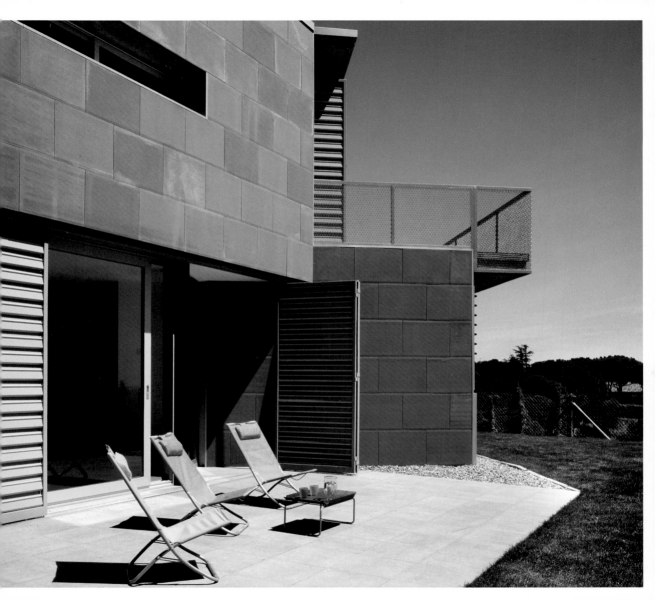

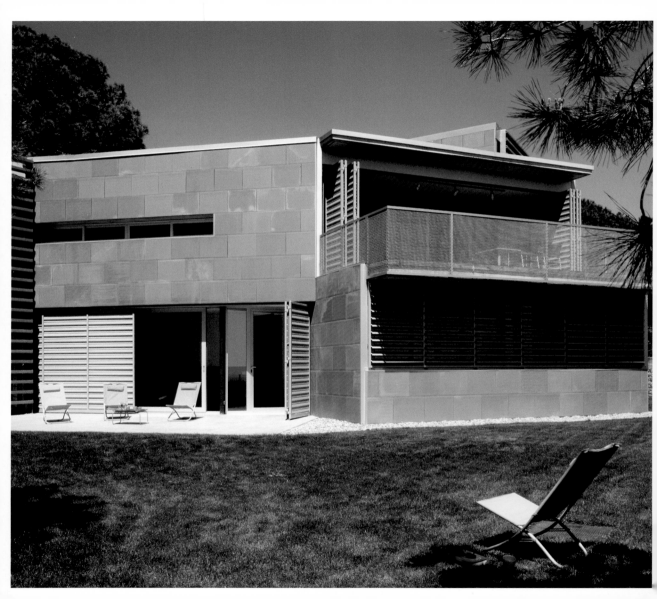

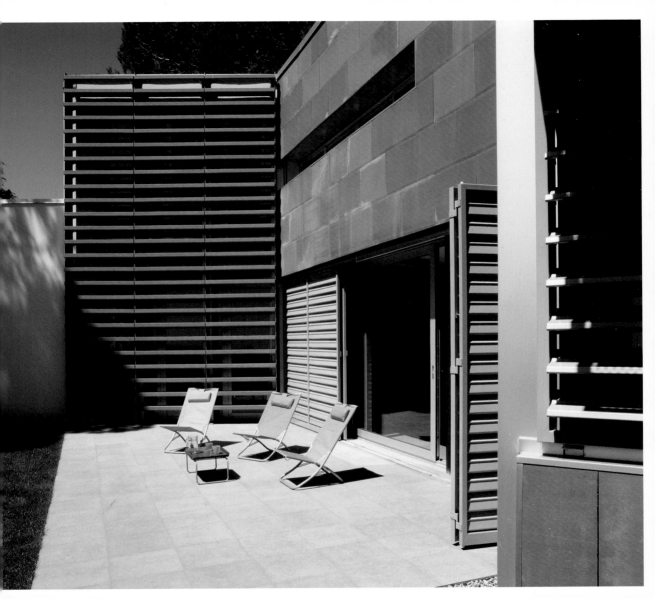

Graftworks Architecture + Design | New York, USA
Greenwich Roof Garden
New York, USA | 2004

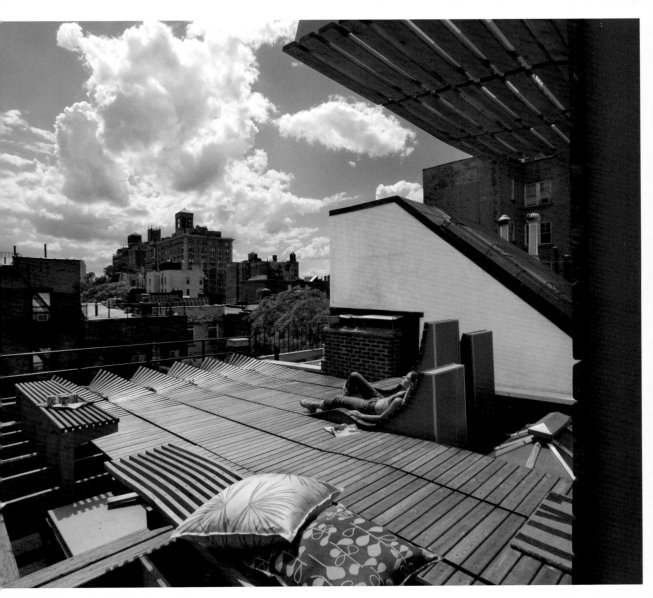

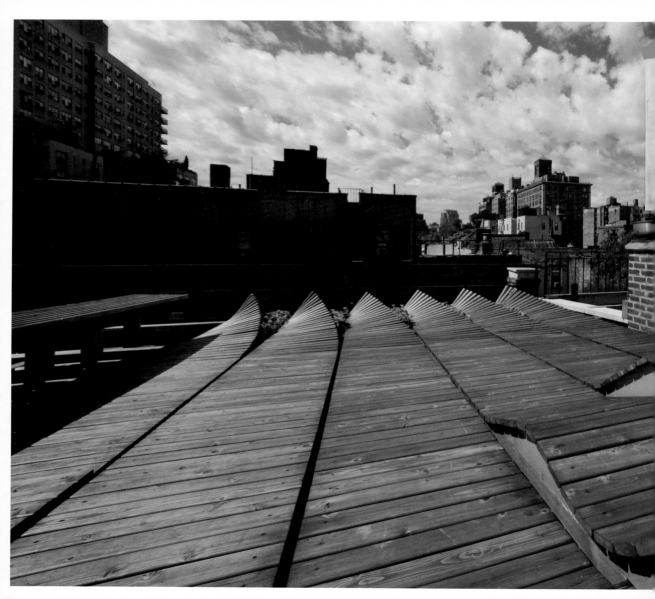

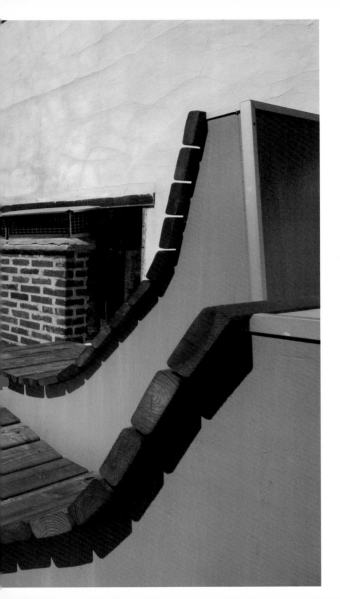

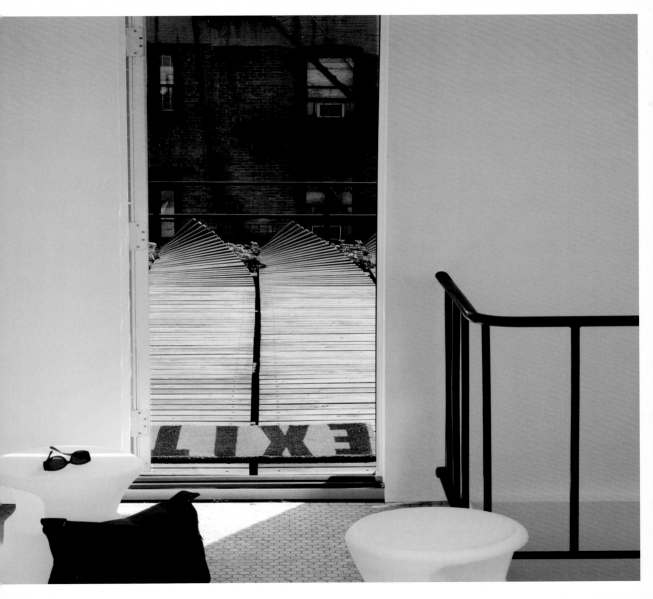

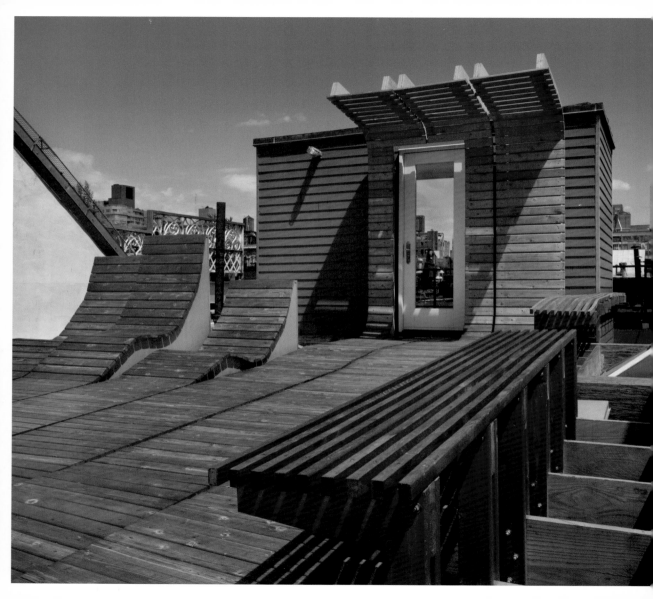

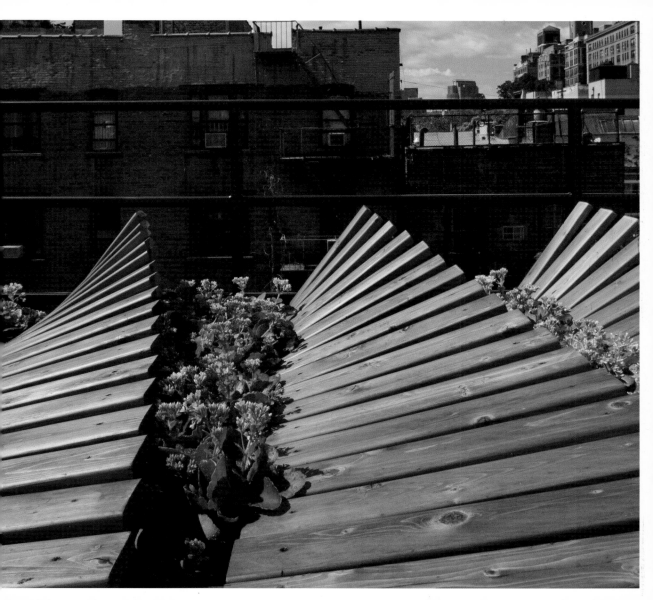

Jaime Guzmán, Fernando Ogarrio | Mexico DF, Mexico
Borja Residence
Mexico DF, Mexico | 2003

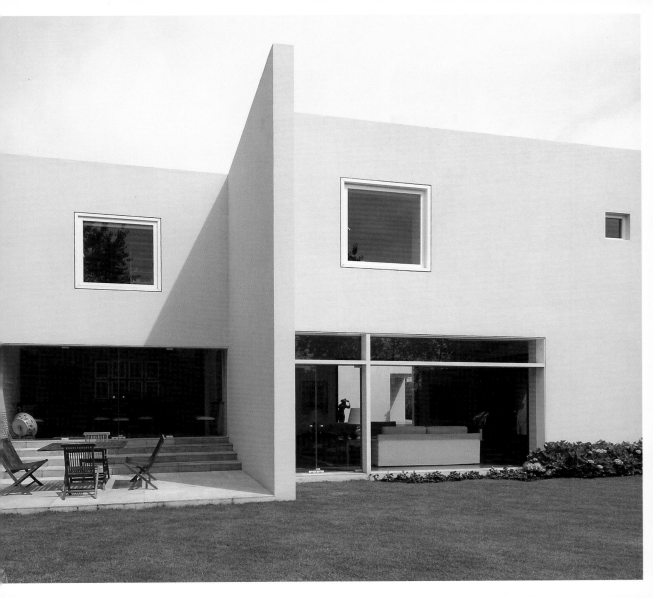

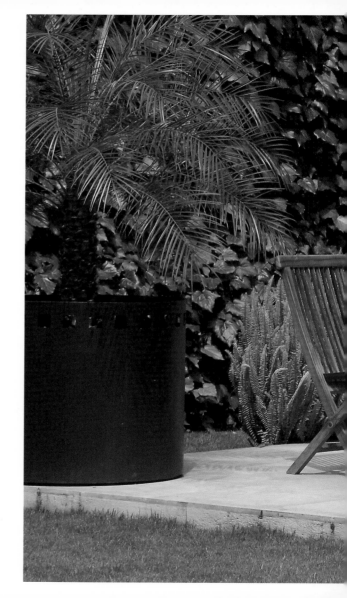

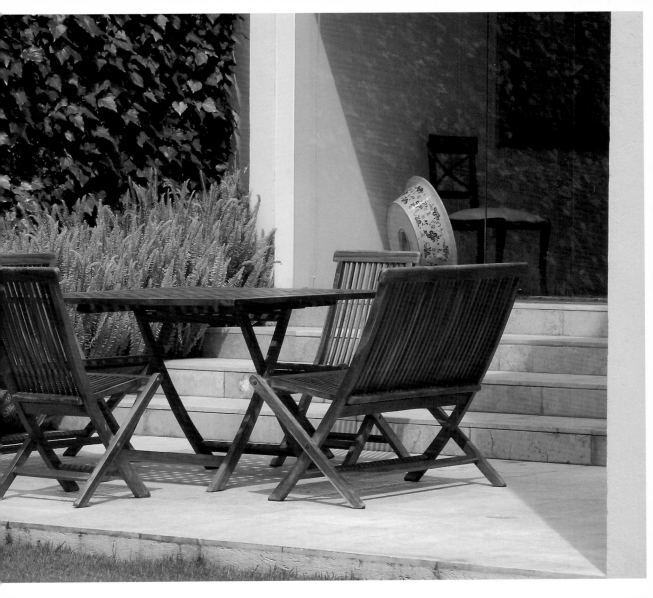

Jaime Sanahuja | Castellón, Spain
Toran House
Oropesa de Mar, Spain | 2003

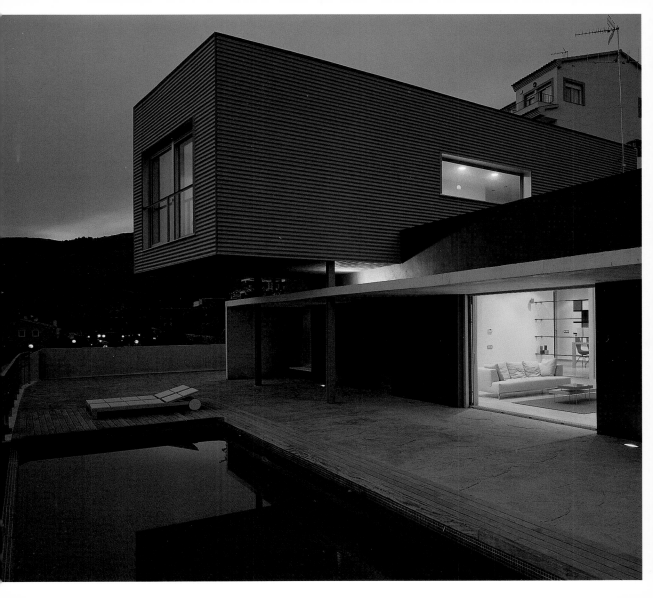

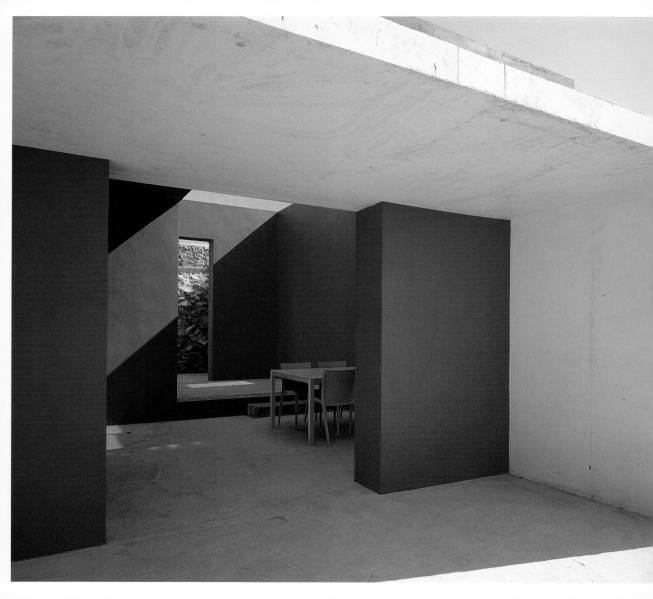

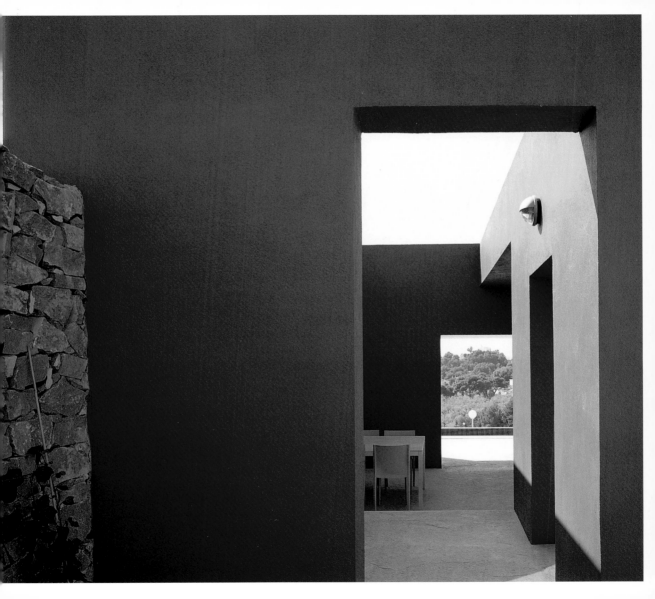

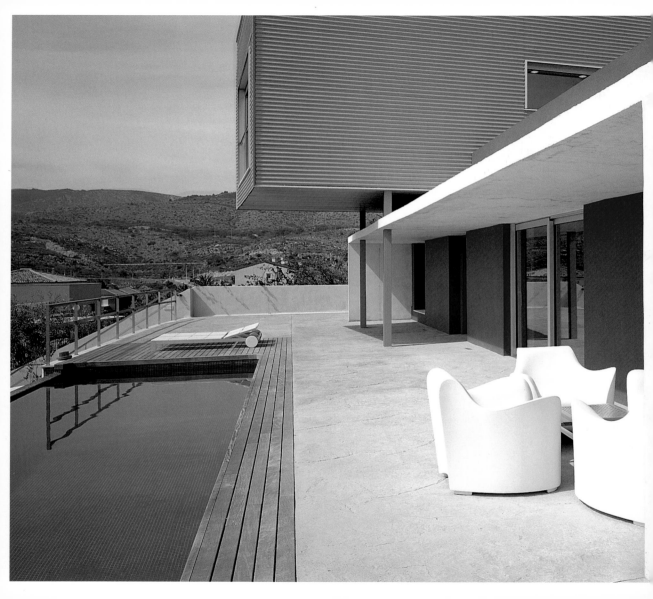

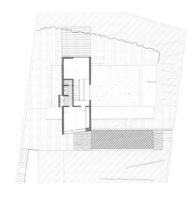

Katerina Tsigarida Architects | Thessaloniki, Greece
Holiday House
Andros Islands, Greece | 2004

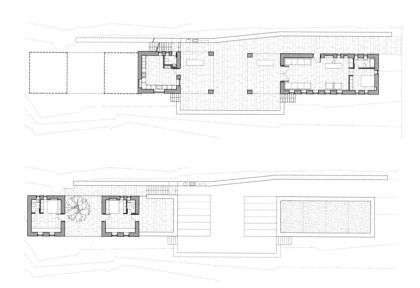

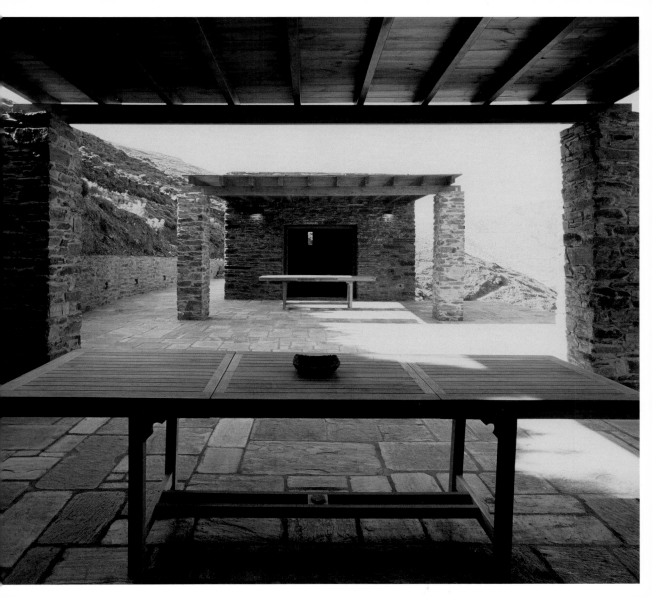

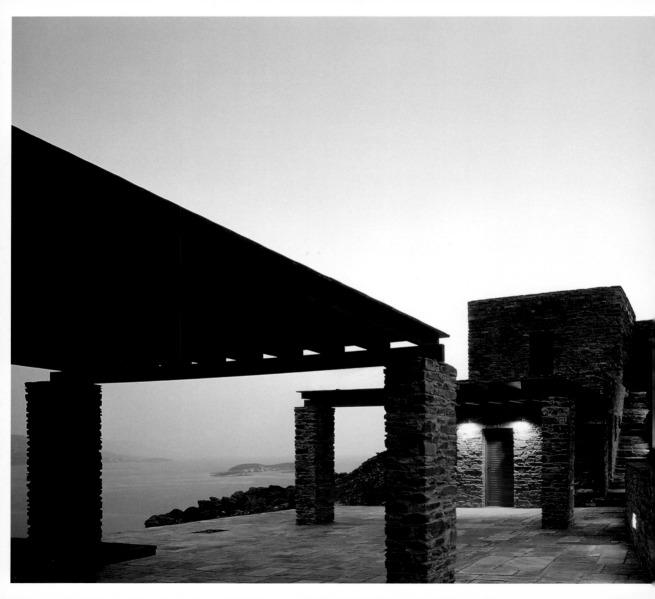

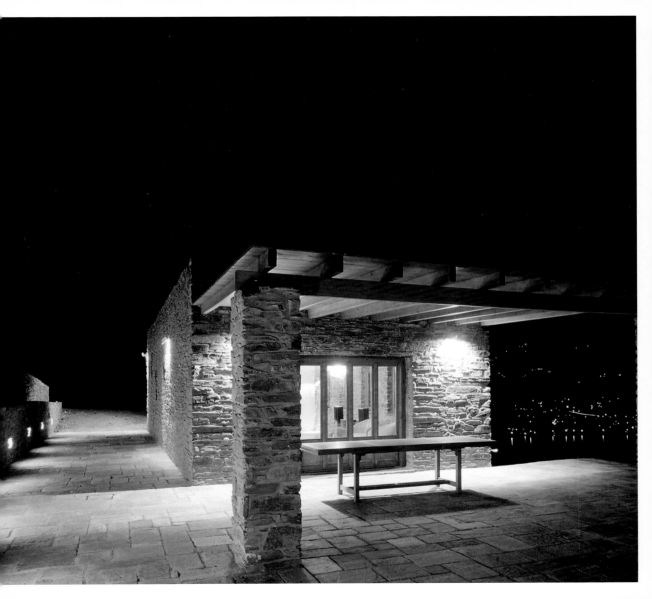

Lazzarini Pickering | Rome, Italy
Positano Villa
Salerno, Italy | 2004

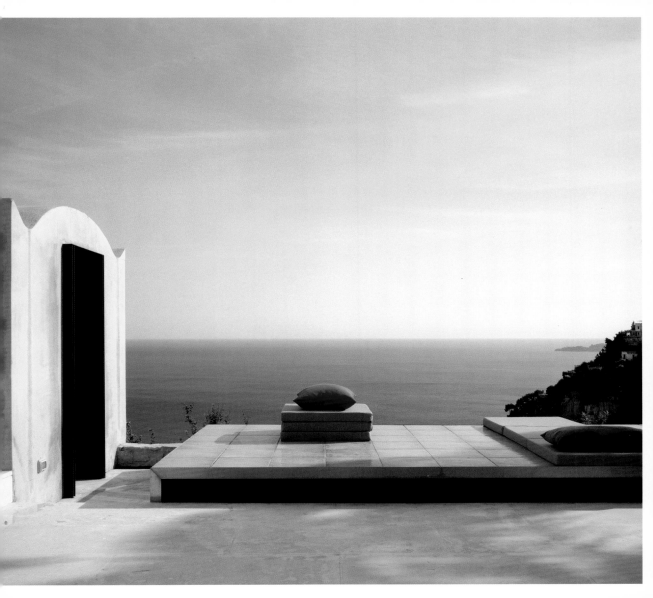

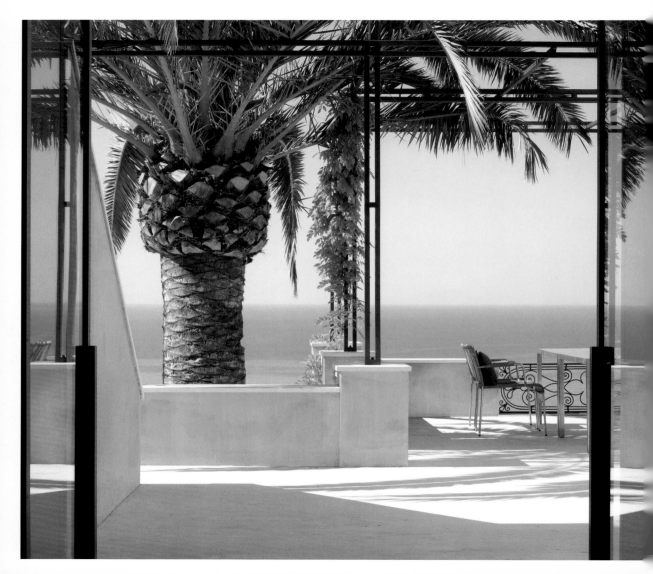

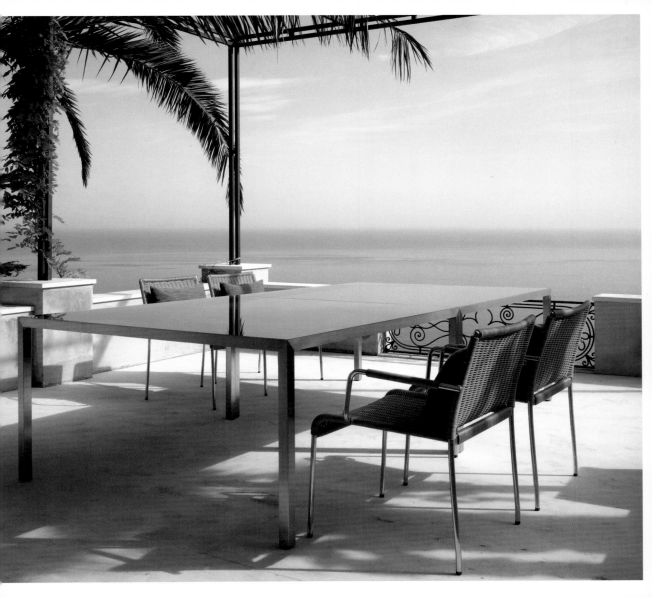

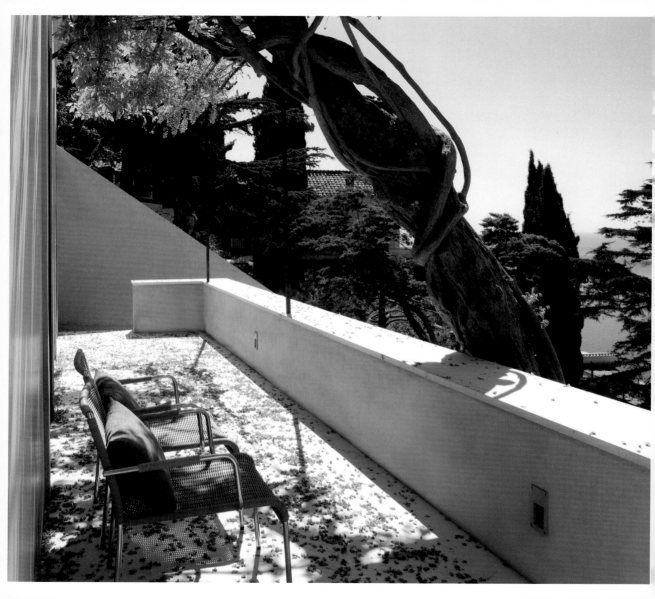

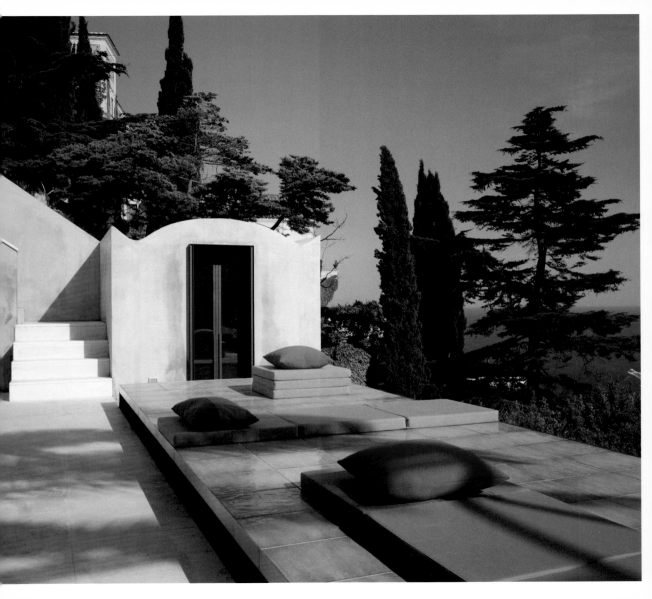

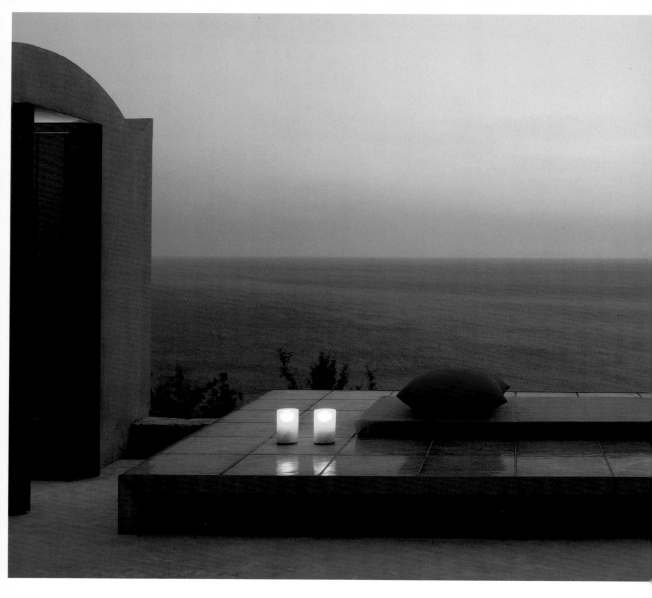

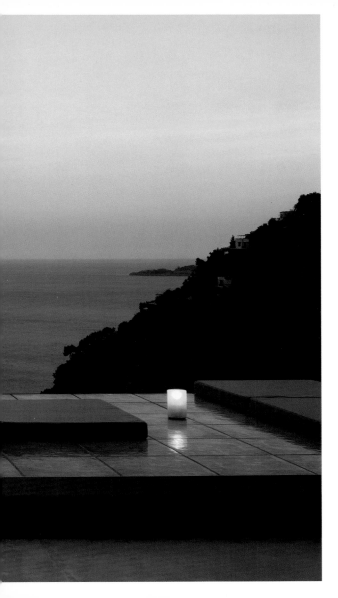

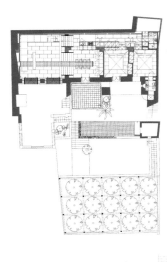

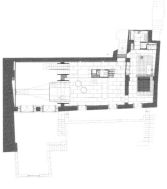

London Town PLC | London, UK
The Bridge
London, UK | 2003

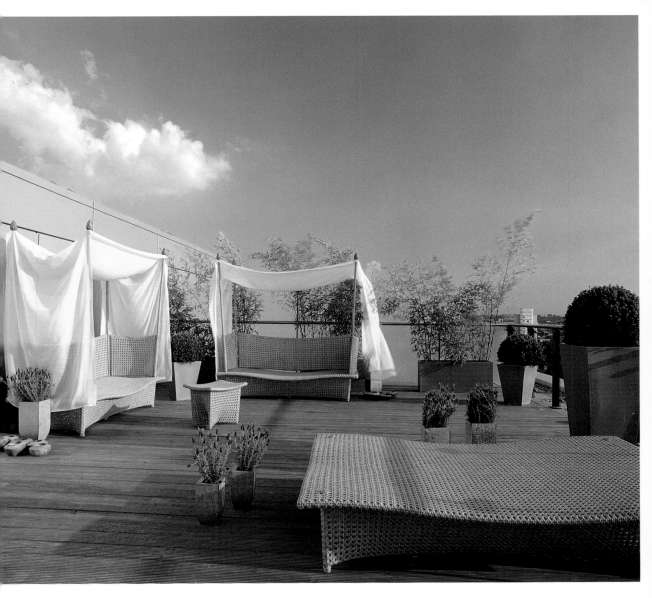

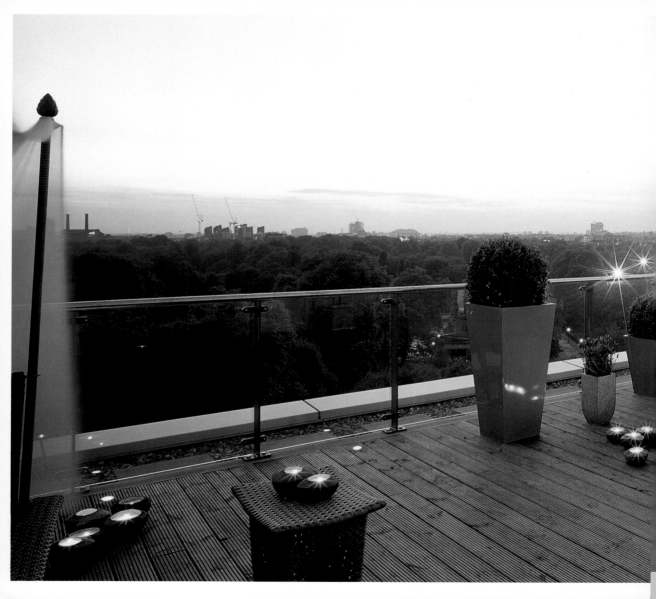

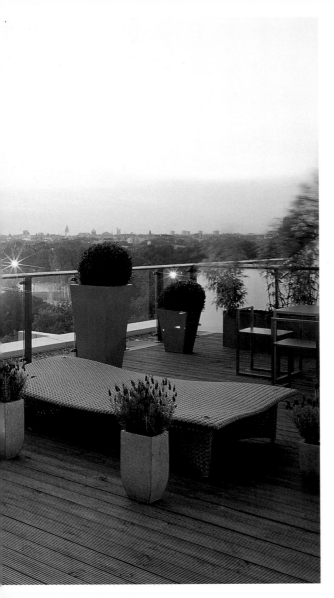

Magín Ruiz de Albornoz | Valencia, Spain
Beach Condos
Valencia, Spain | 2003

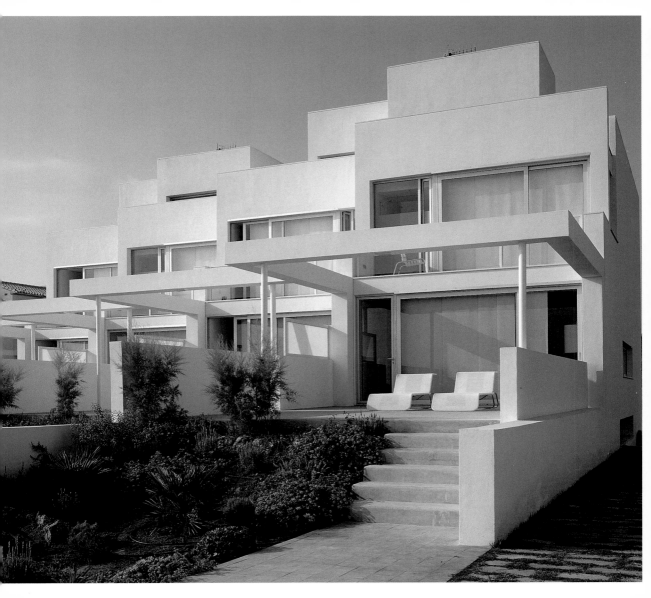

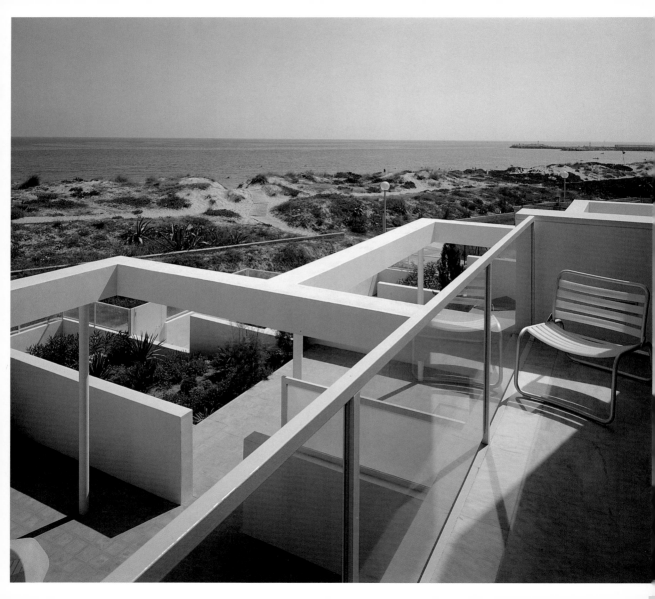

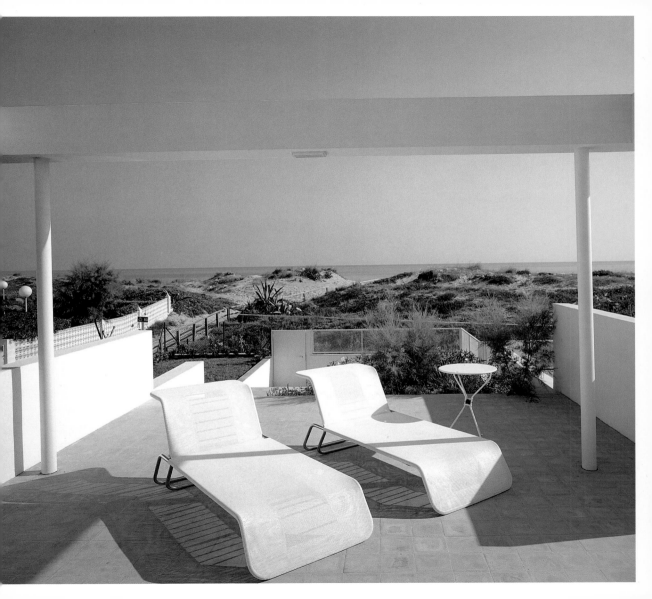

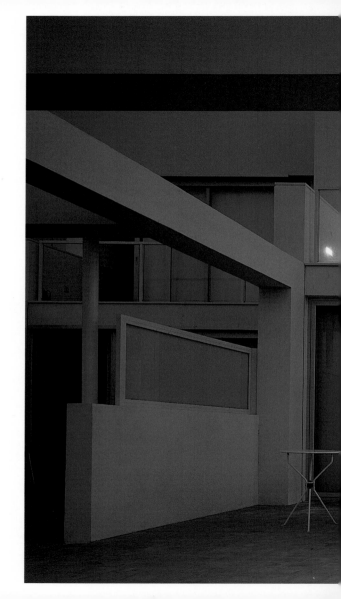

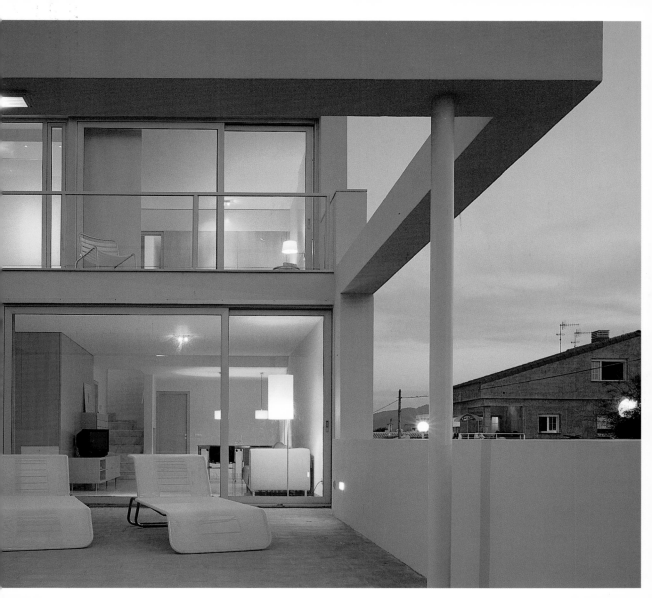

Magín Ruiz de Albornoz | Valencia, Spain
Bétera House
Valencia, Spain | 2001

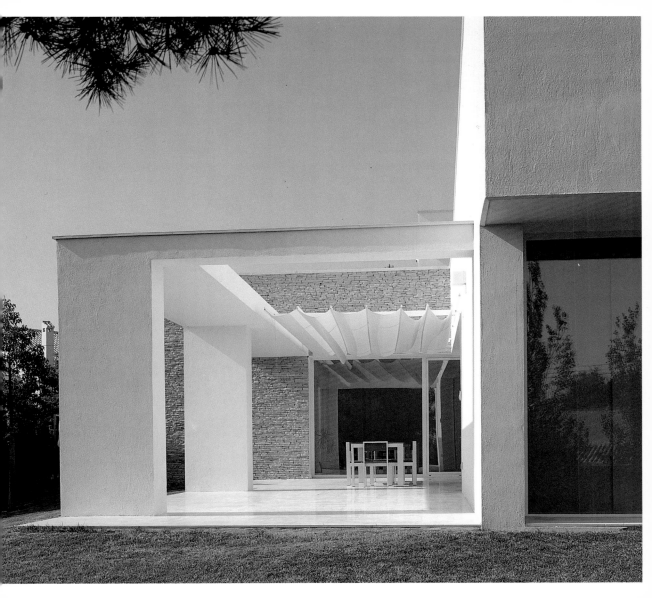

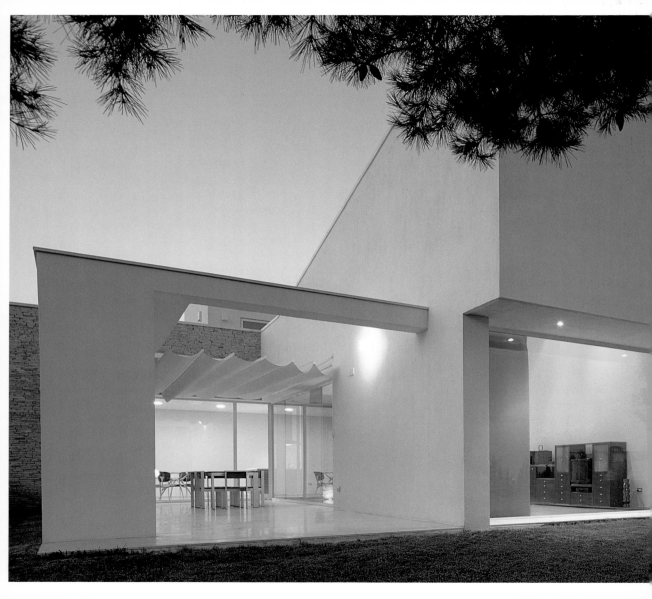

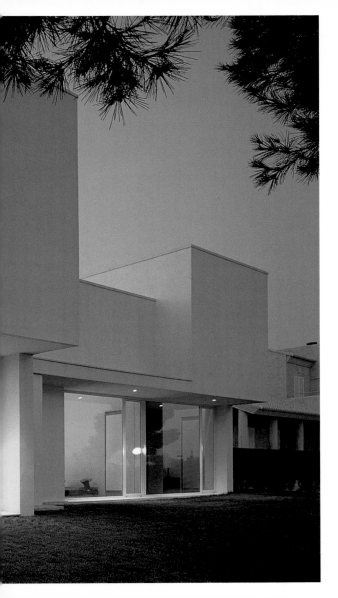

MAP Arquitectos/Josep Lluís Mateo | Barcelona, Spain
Summer House
Mallorca, Spain | 2001

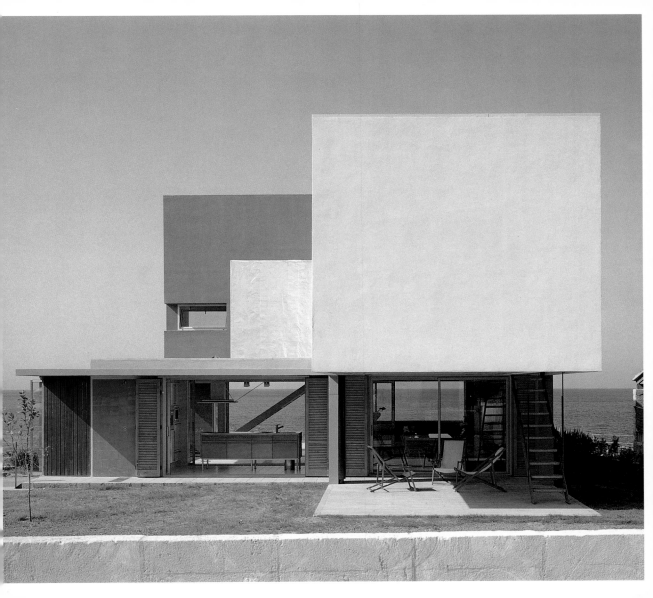

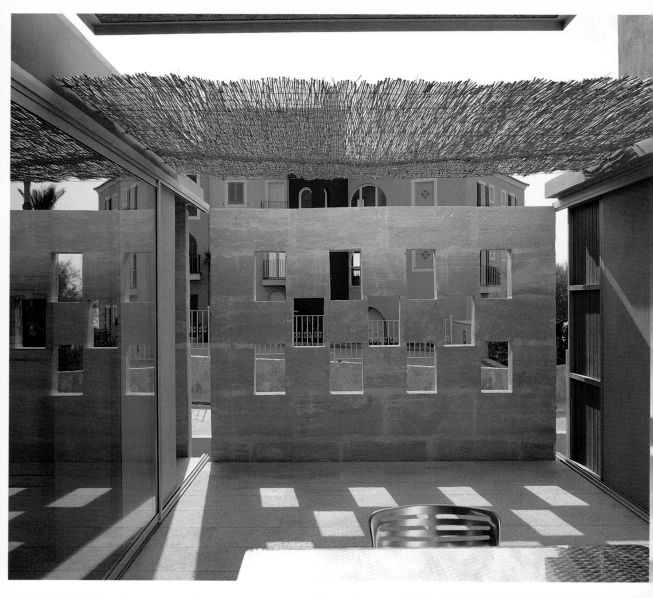

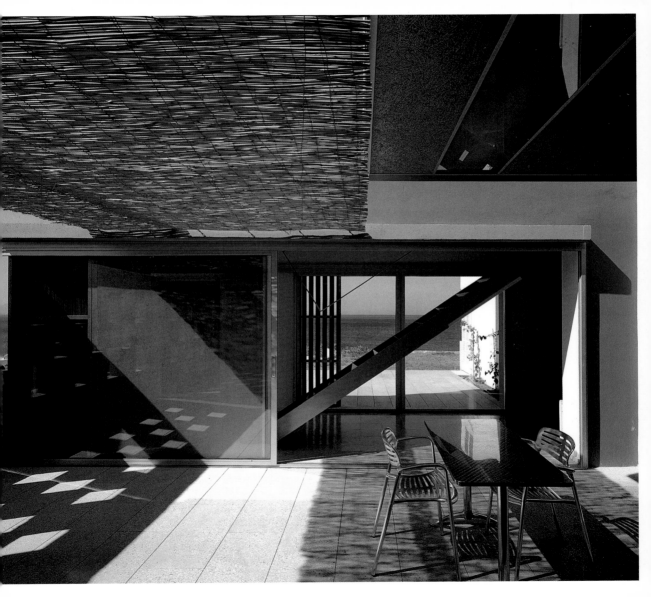

Marcio Kogan Architects | São Paulo, Brazil
BR House
Araras, Brazil | 2004

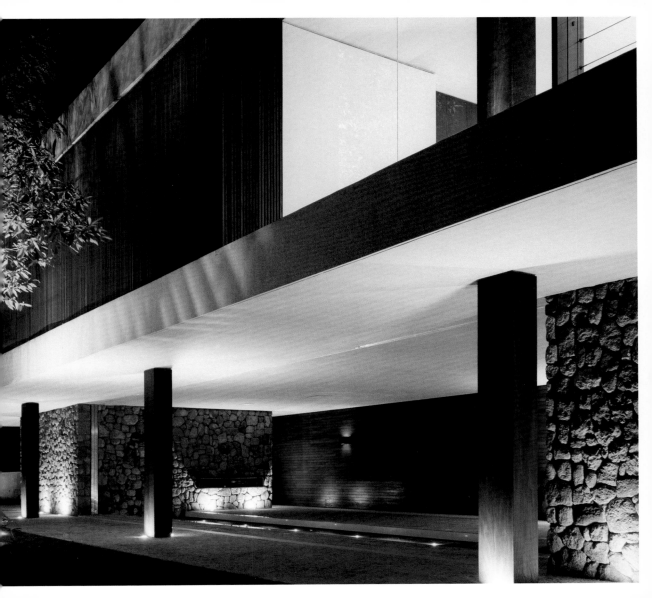

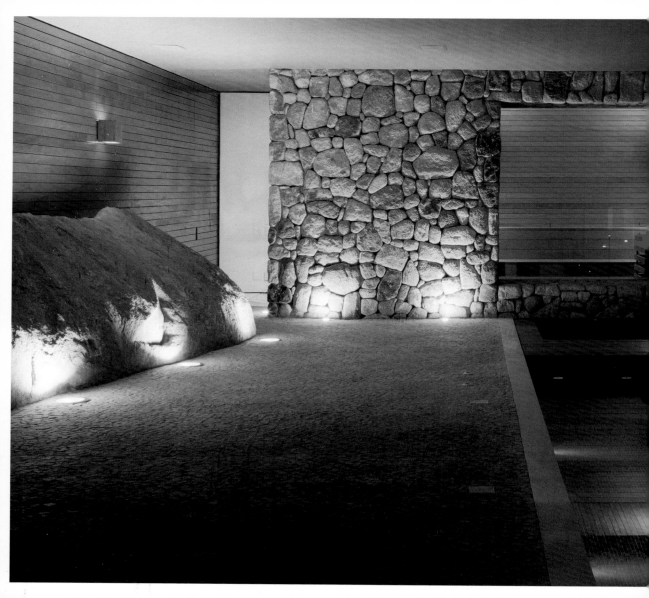

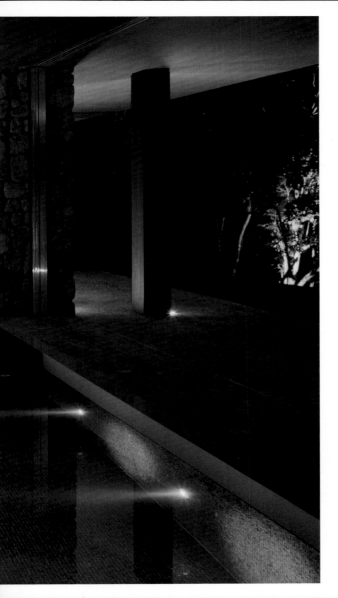

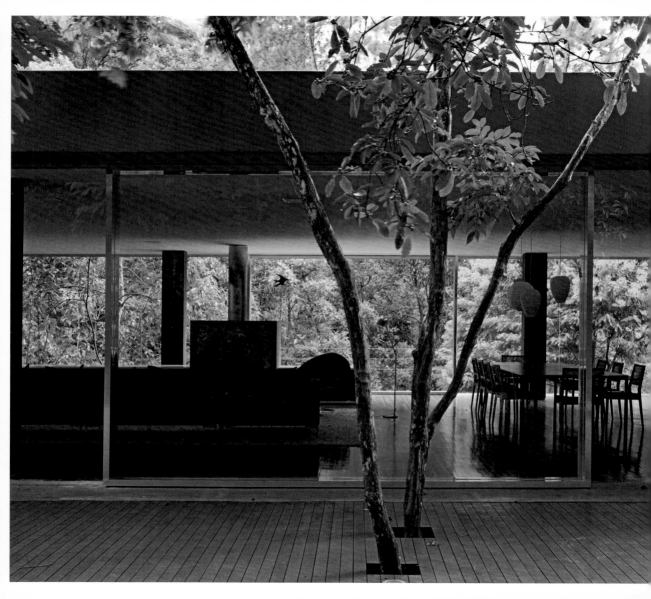

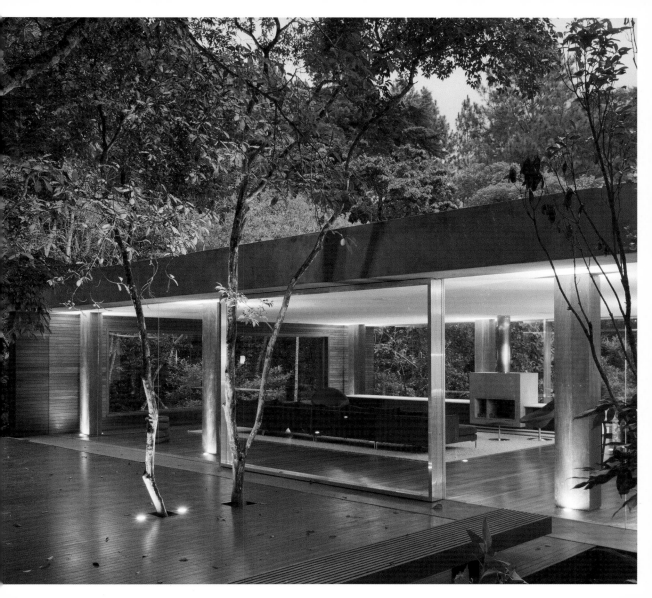

Marcio Kogan Architects | São Paulo, Brazil
D'Andrea Henkin House
São Paulo, Brazil | 2003

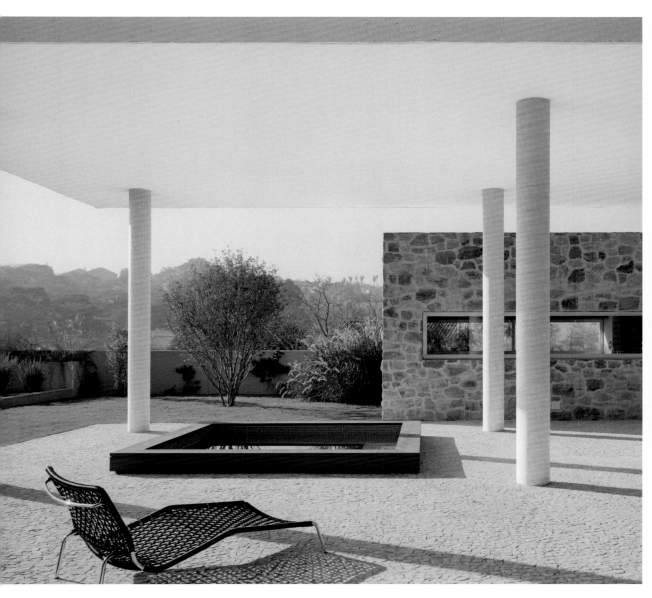

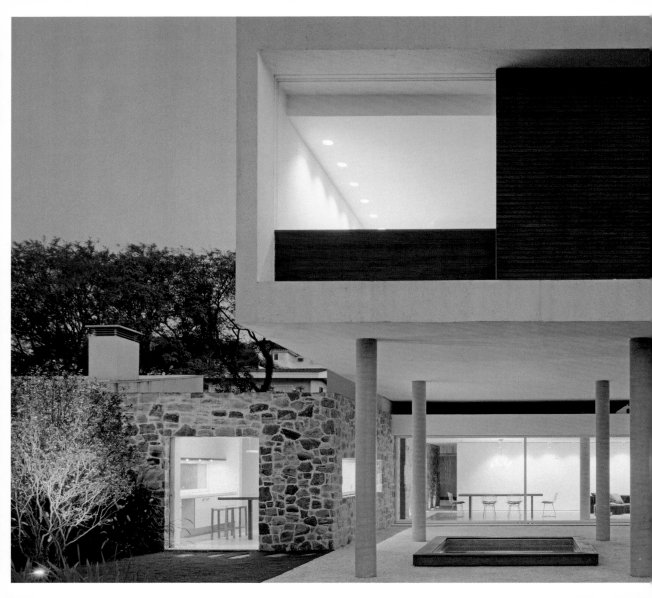

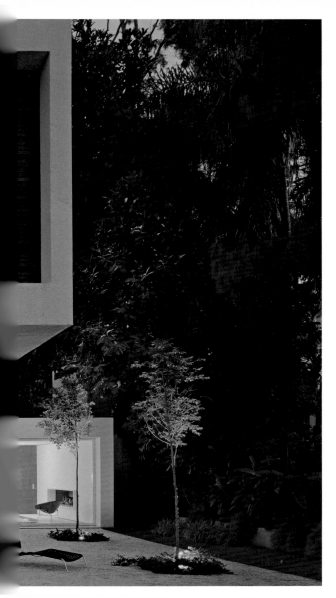

Marcio Kogan Architects | São Paulo, Brazil
Quinta House
Bragança Paulista, Brazil | 2004

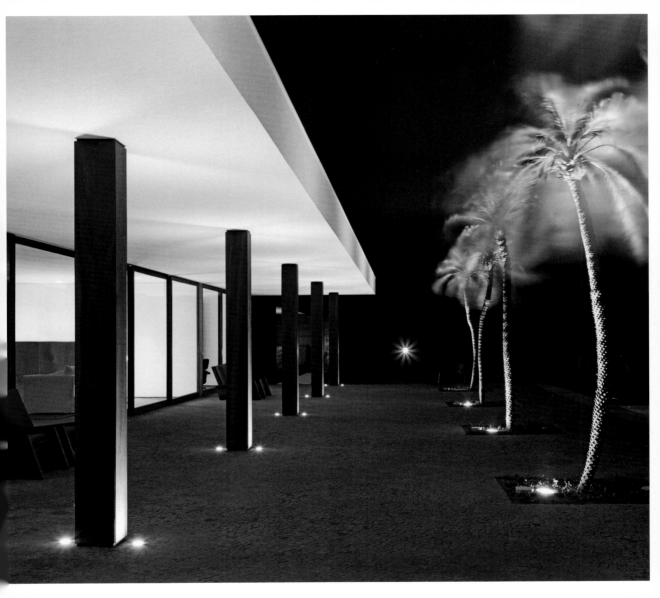

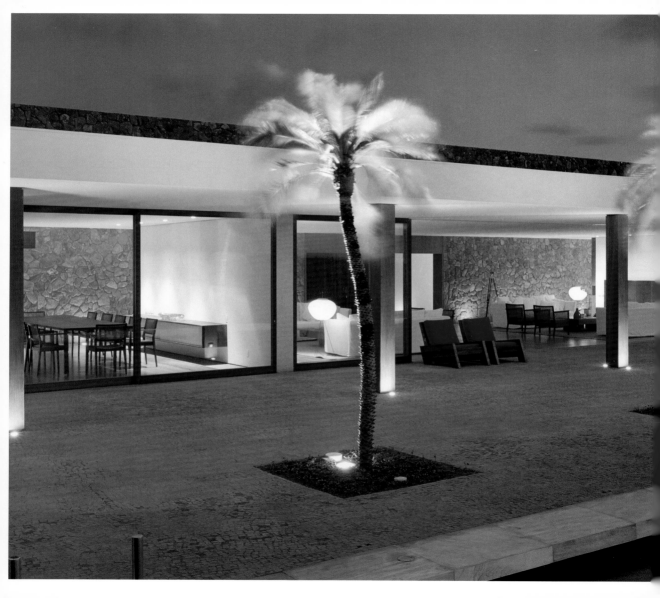

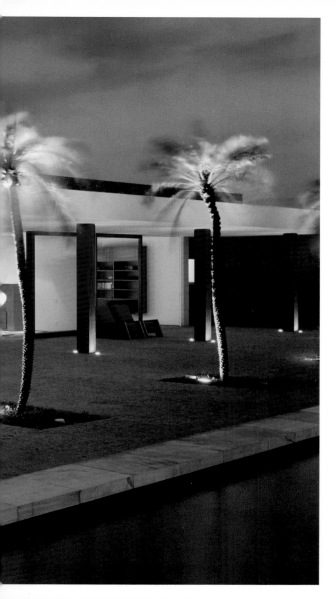

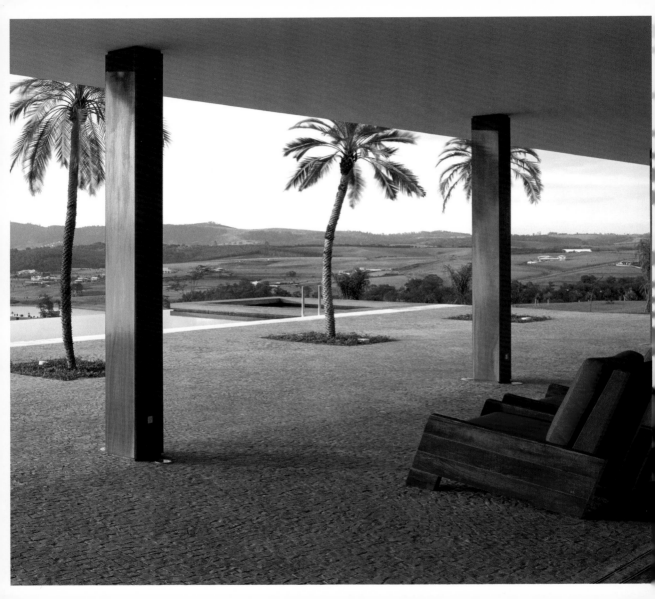

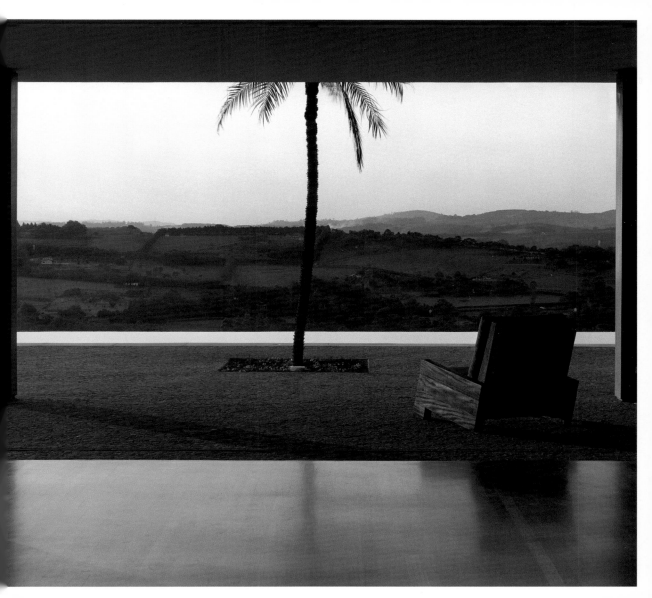

Prima Design | Florence, Italy
Portman Residence
New York, USA | 2003

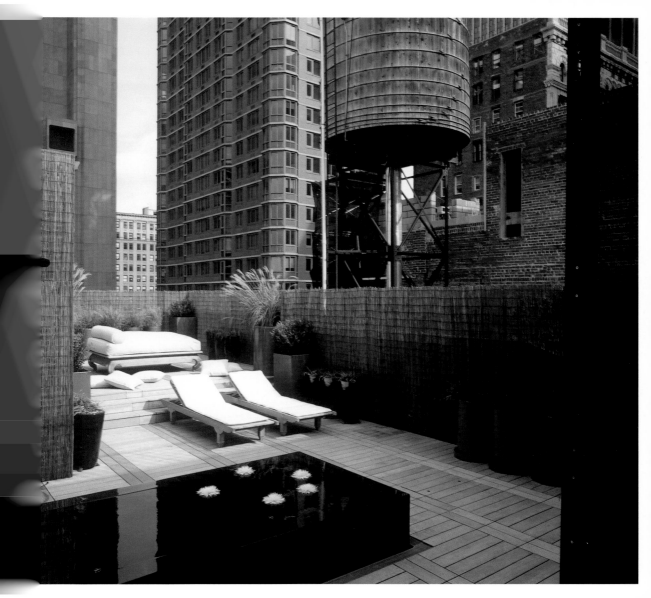

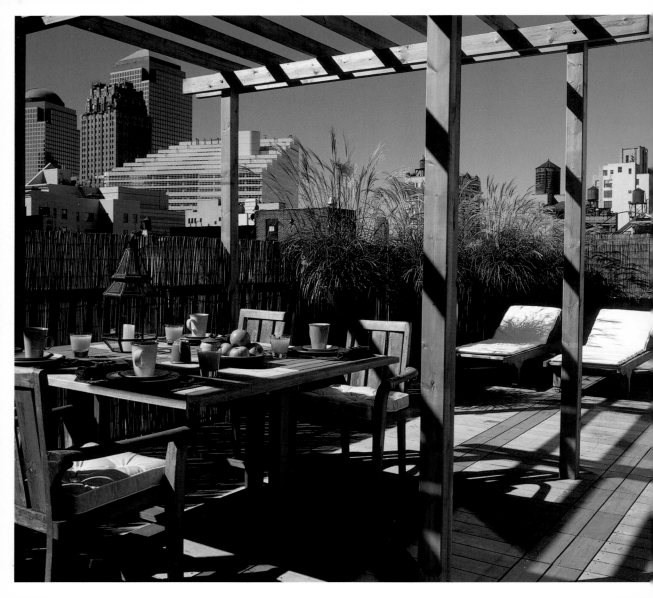

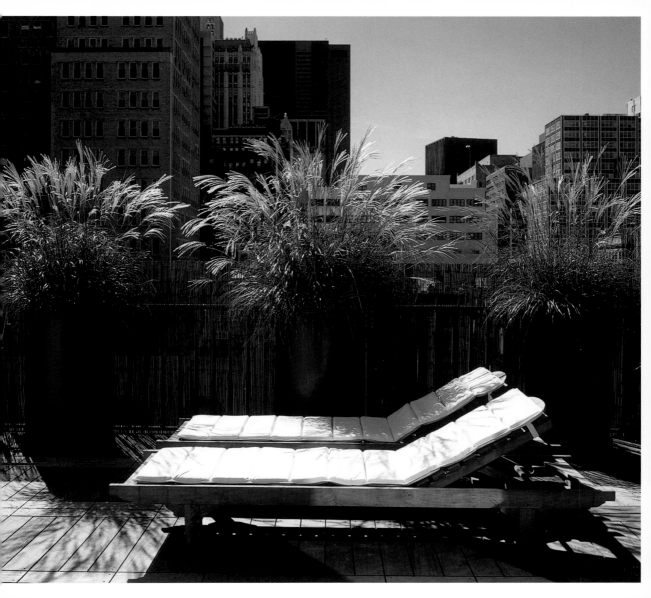

Reinach Mendonça Arquitetos Associados | São Paulo, Brazil
Glass House
Bragança Paulista, Brazil | 2004

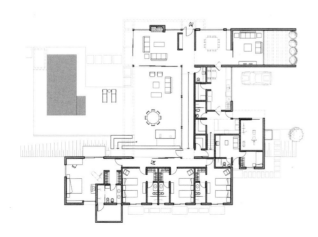

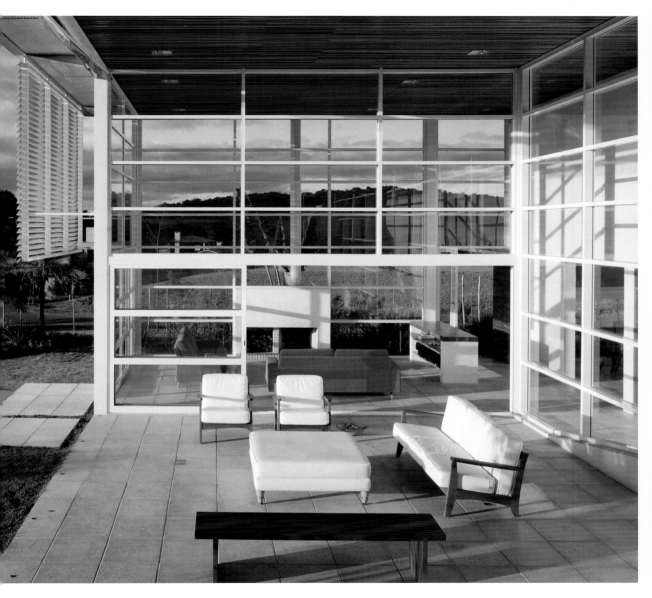

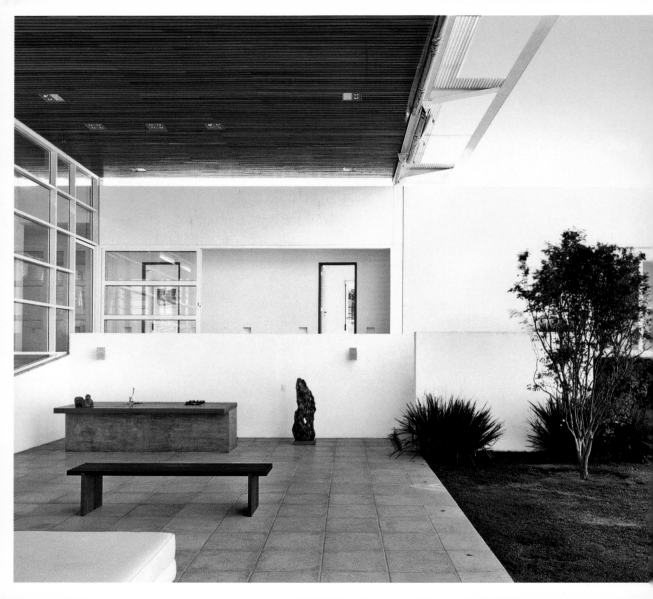

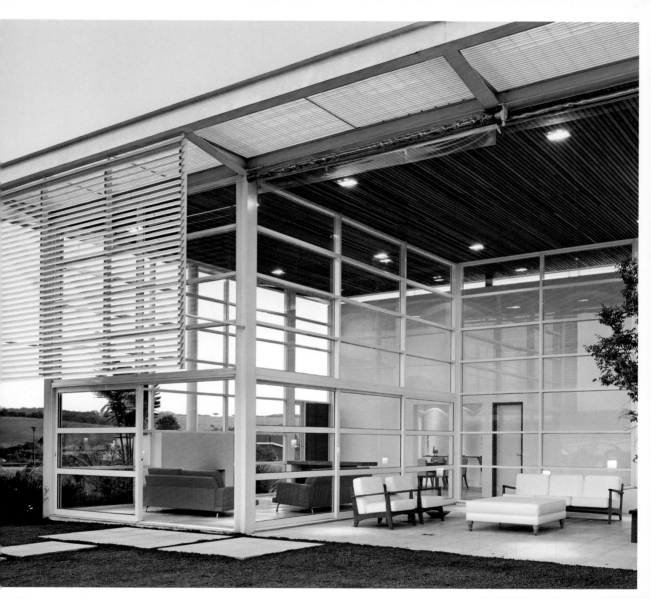

Ricardo Legorreta | Mexico DF, Mexico
Lourdes Residence
Valle del Bravo, Mexico | 2003

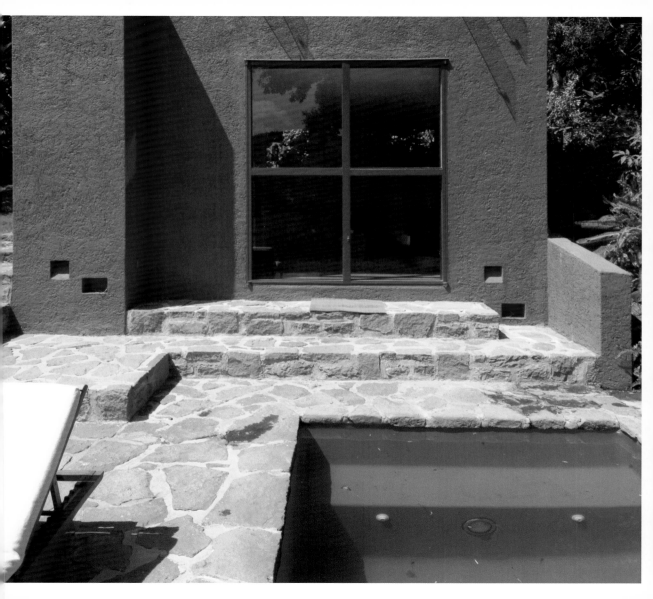

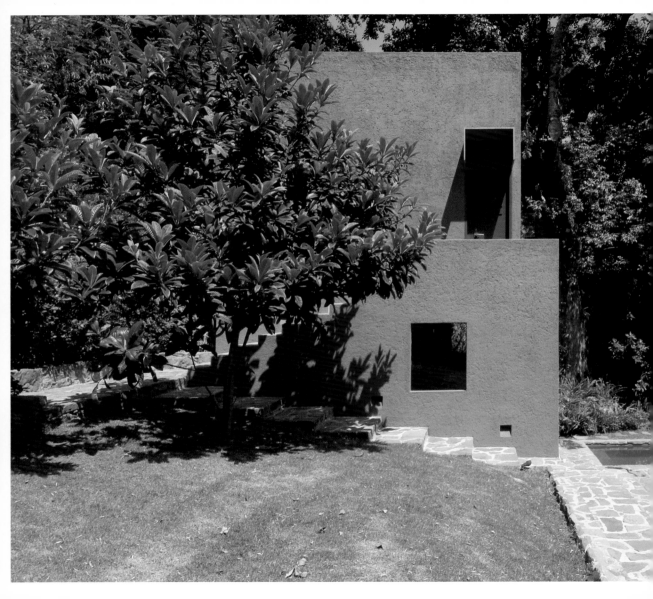

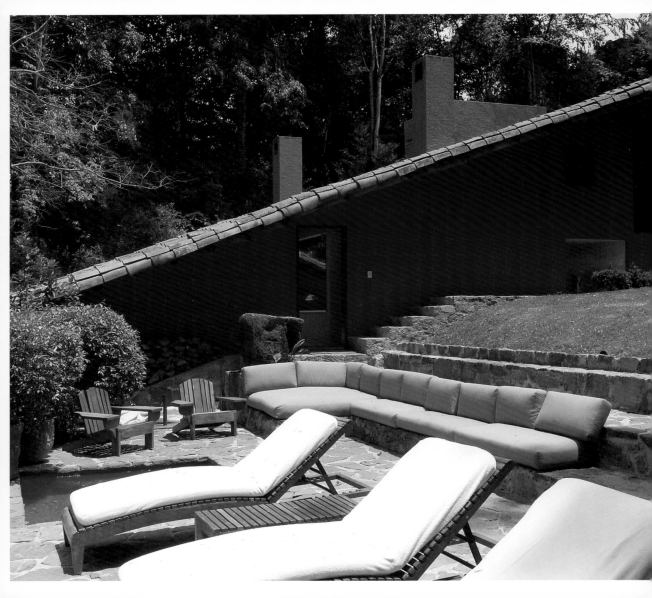

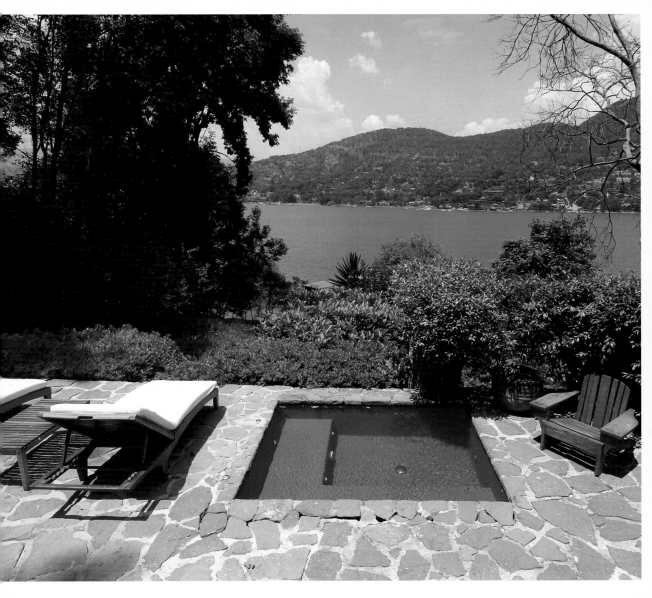

Riegler Riewe | Graz, Austria
Penthouse T
Graz, Austria | 2004

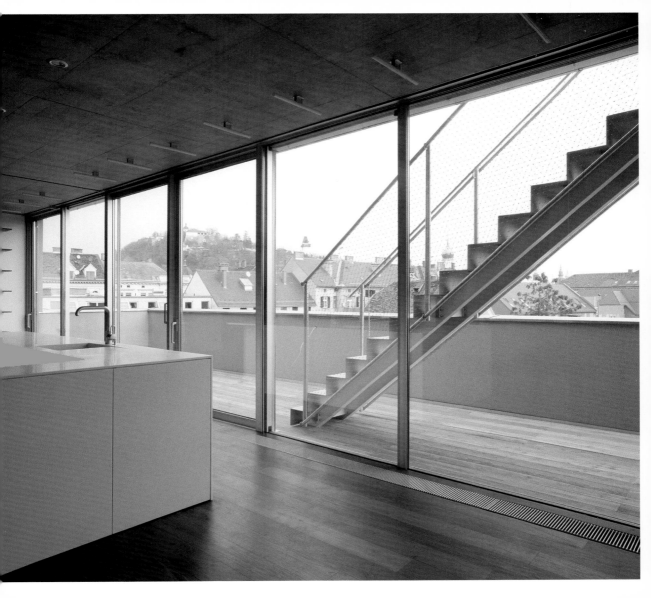

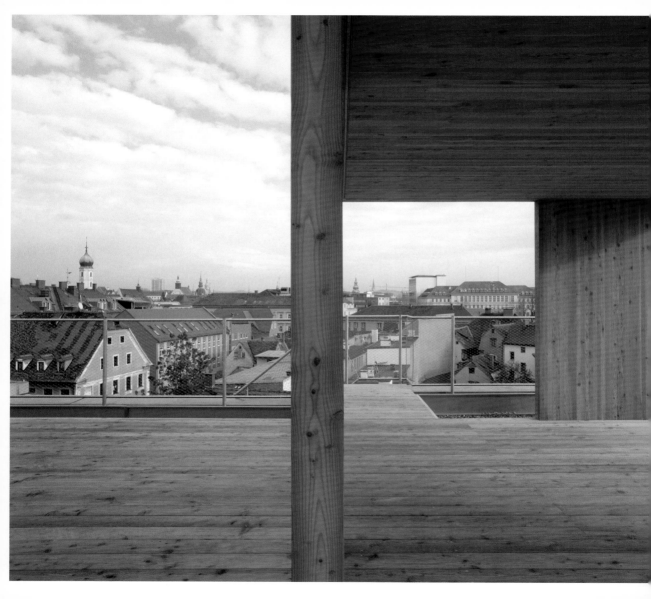

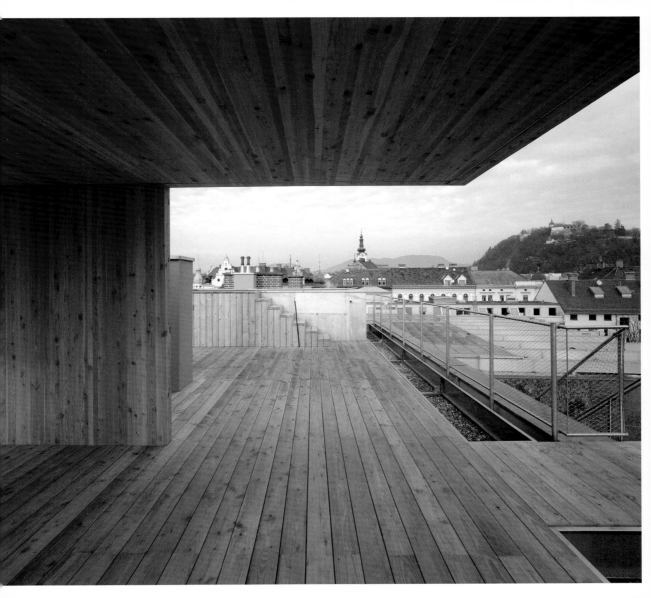

Rios Clementi Hale Studios | Los Angeles, California, USA
Brentwood Pool & Terrace
Brentwood, California, USA | 2002

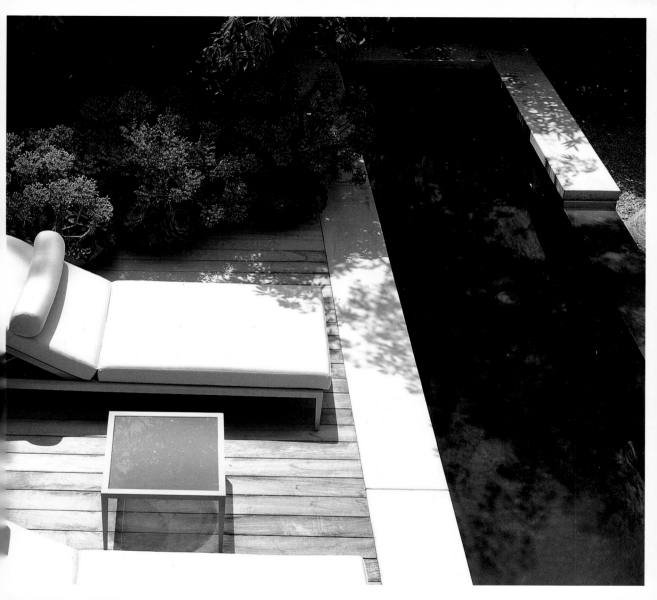

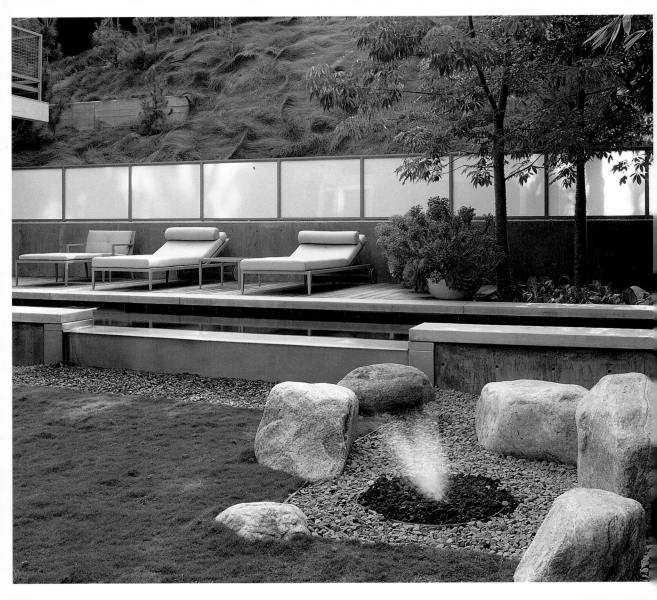

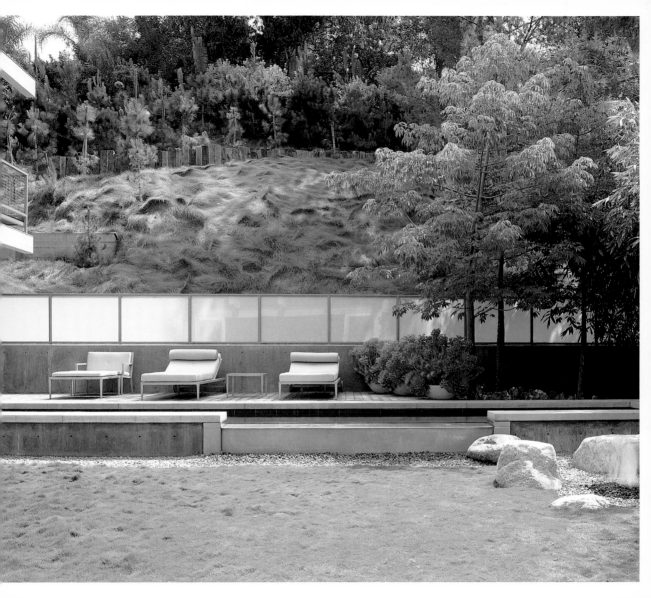

Safdie Rabines Architects | San Diego, California, USA
Treehouse
San Diego, California, USA | 2000

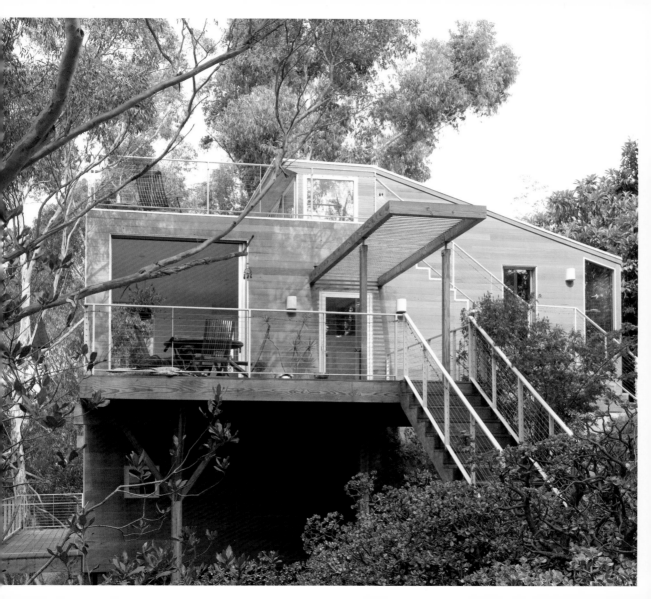

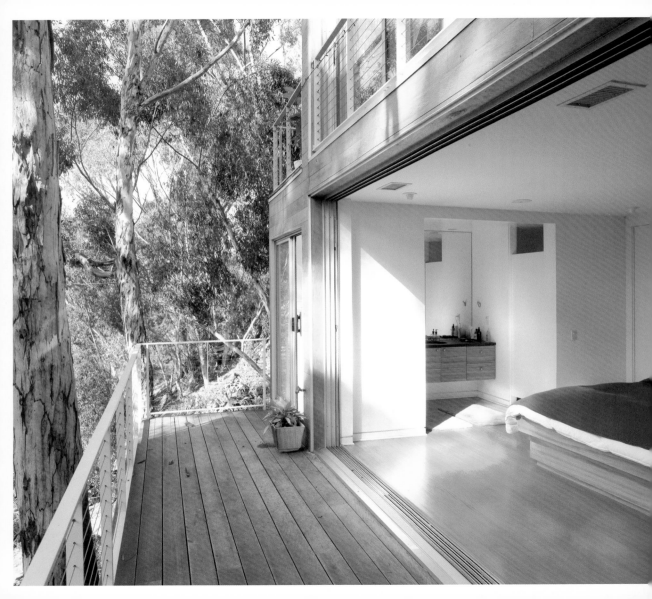

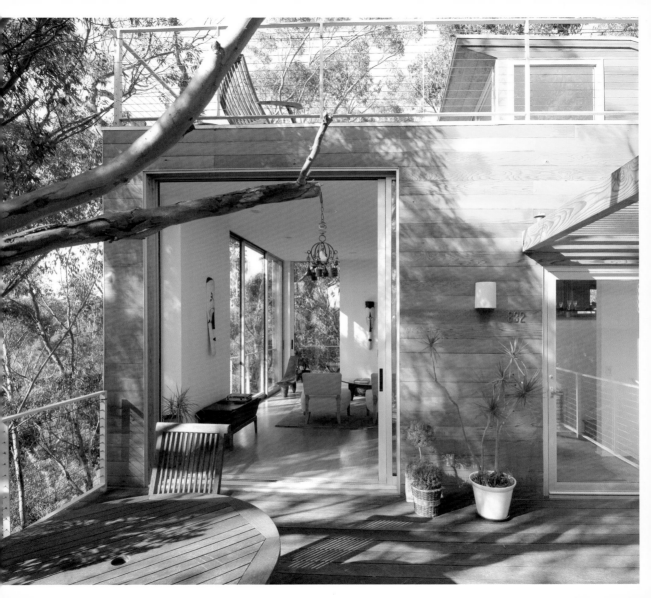

**Studio Architetti Associati di Andrea Lenzi e
Stefano Bernardi | Savignano sul Rubicone, Italy**
San Giuliano Mare Residence
Rimini, Italy | 2003

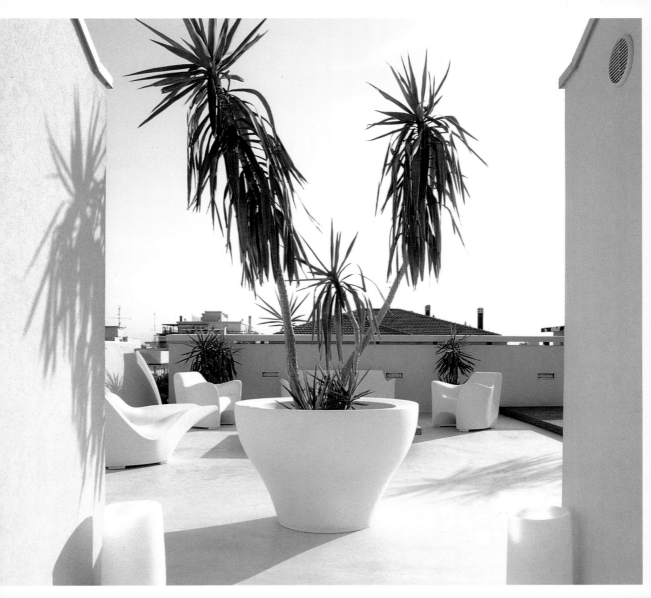

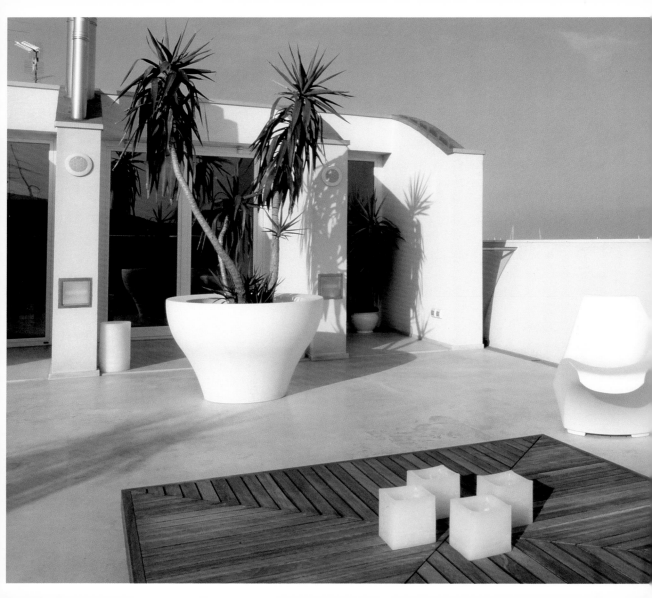

StudioMAS/Pierre Swanepoel | Johannesburg, South Africa
Westcliff Estate
Johannesburg, South Africa | 2002

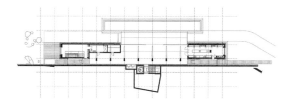

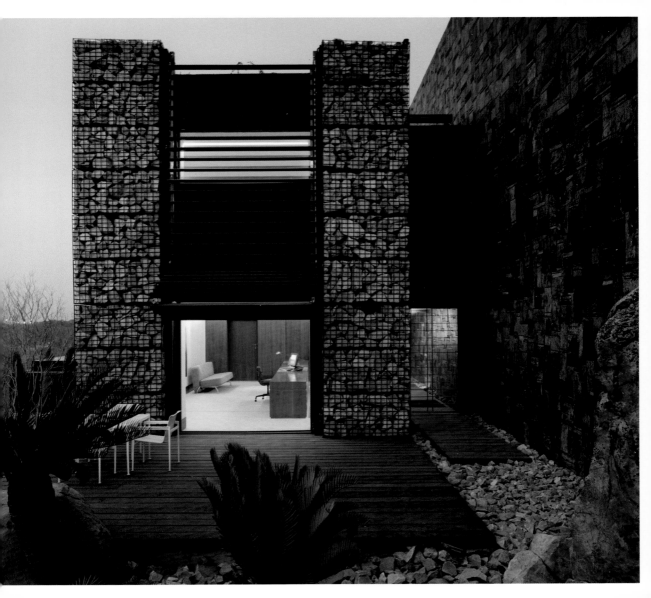

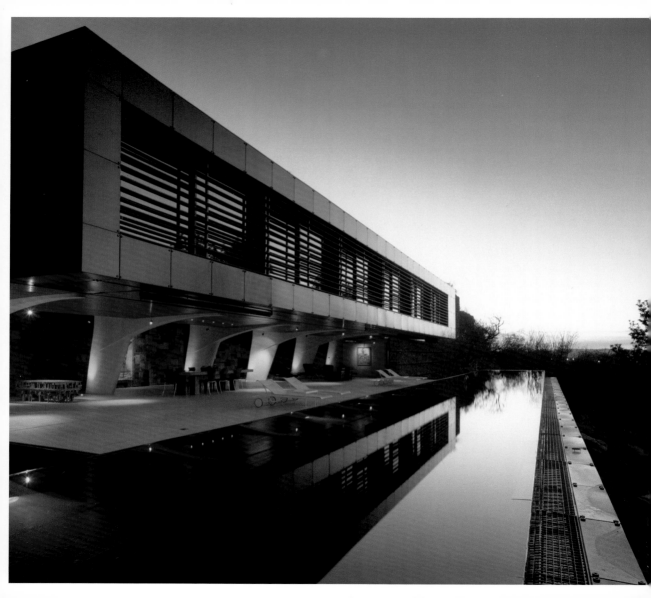

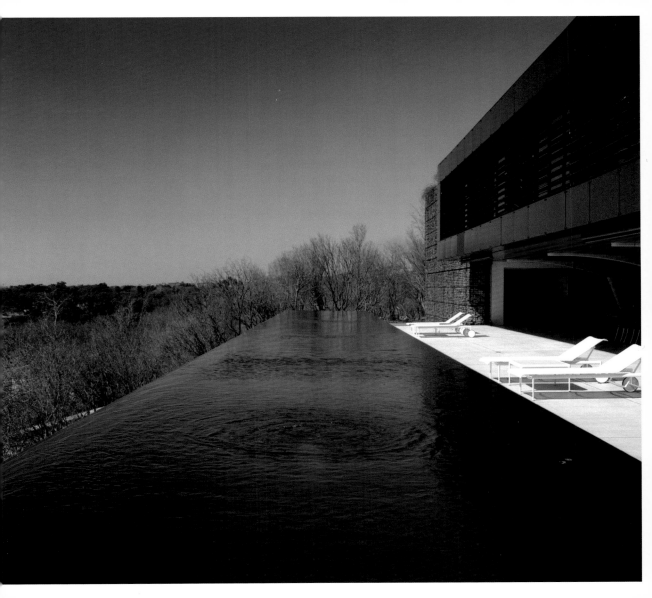

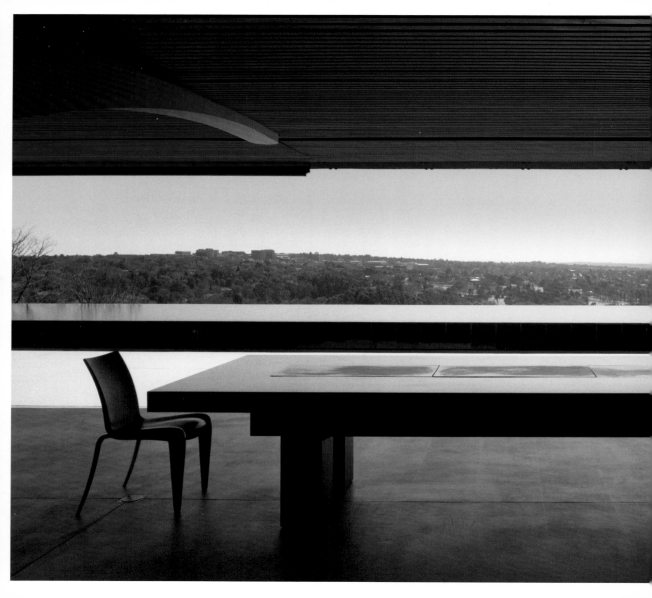

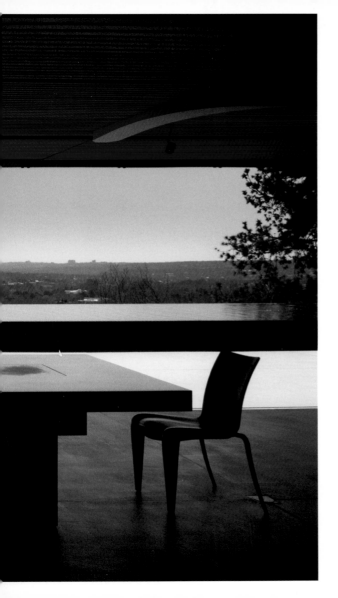

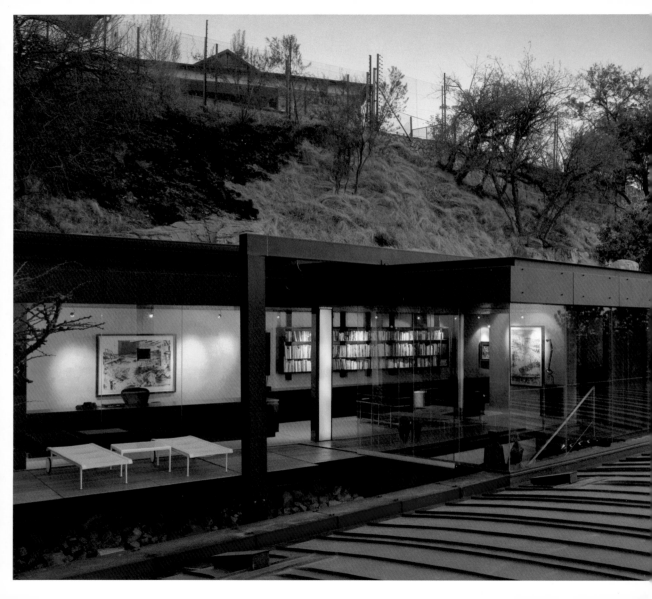

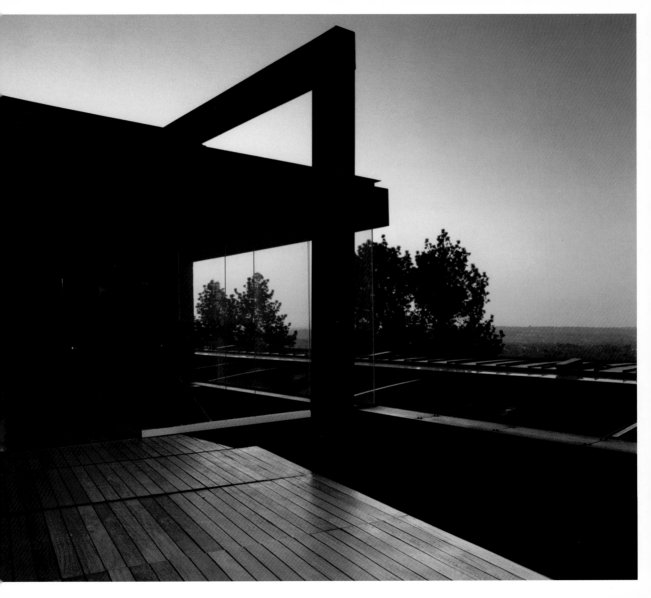

Thornsett Group | London, UK
Marjory Street Terrace
London, UK | 2003

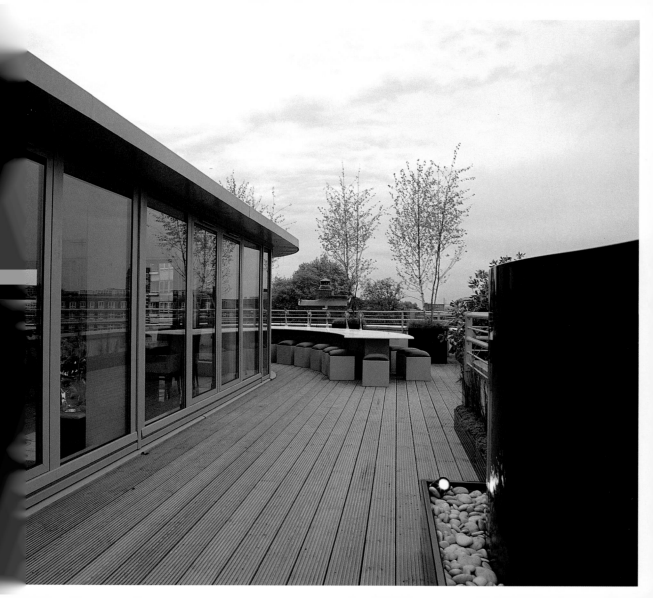

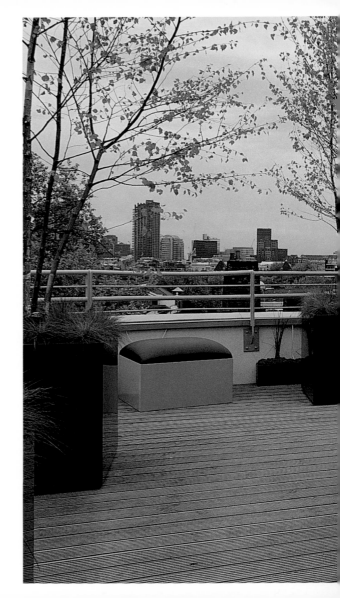

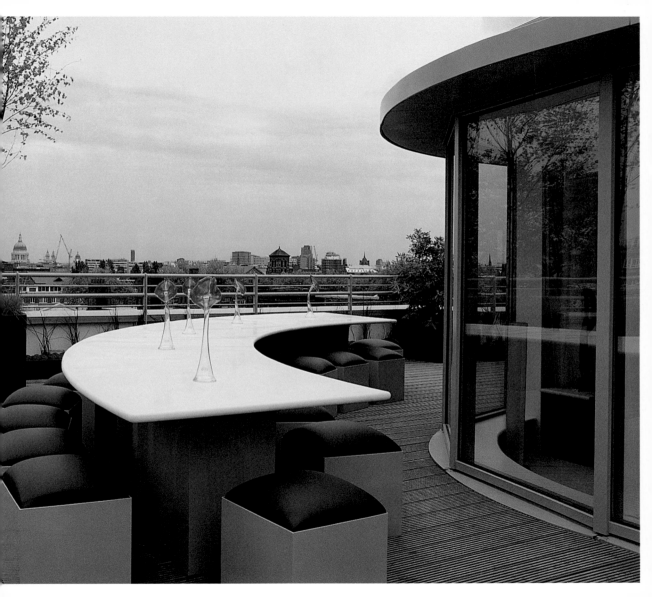

Wolfgang Ritsch | Dornbirn, Austria
Abrederis Residence
Rankweil, Austria | 2002

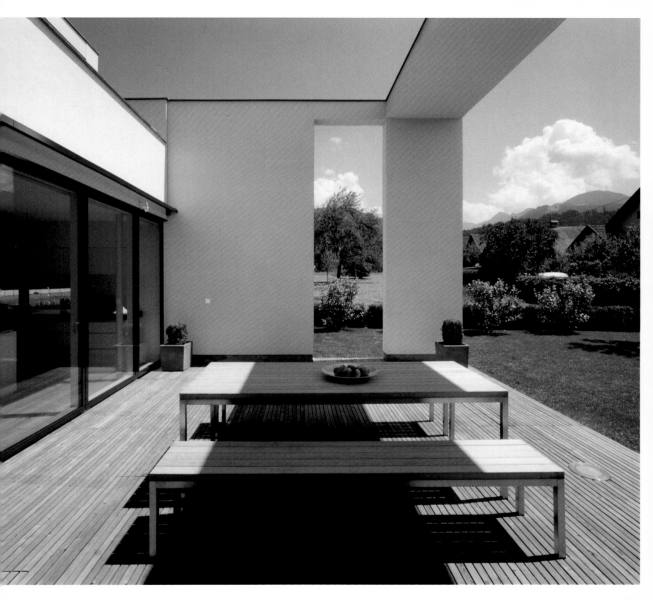

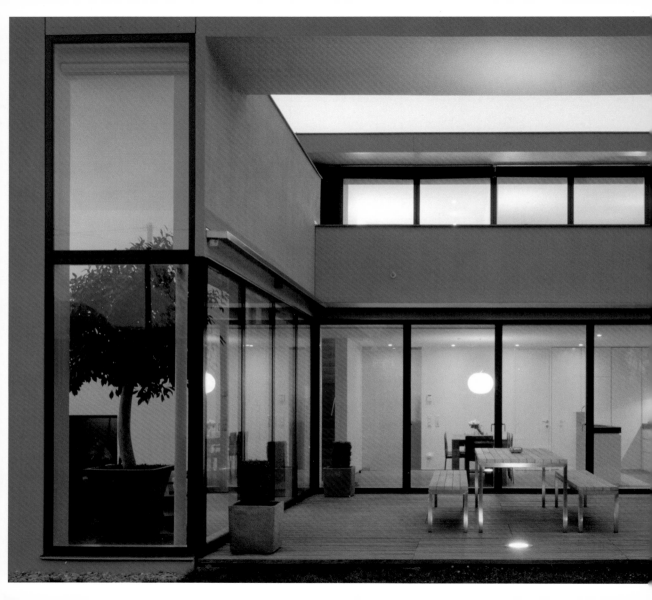

Alberto Burckhardt
Cra. 9 N.º 75-50 Apt. 502
Bogotá, Colombia
P +57 13217483
F +57 13417008
albertoburckhardt@hotmail.com
Pierino Residence
Photos: © Alberto Burckhardt, Beatriz Santo Domingo

Alberto Martínez Carabajal
Escuelas Pías 40 bajos
08017 Barcelona, Spain
P +34 934182508
F +34 934182507
martinez.carbajal@coac.net
Girona House
Photos: © Jordi Miralles

Aleks Istanbullu Architects
1659 11th Street Suite 200
Santa Monica, CA 90404, USA
P +1 3104508246
F +1 3103991888
www.ai-architects.com
Hinge House
Photos: © Weldon Brewster

Álvaro Siza
Rua do Aleixo 53-2
4150-043 Porto, Portugal
P +351 226167270
F +351 226167279
www.alvarosiza.com
Céramique Penthouse
Photos: © Duccio Malagamba

Anne Marie Sumner
Rua Alves Guimarães 784
São Paulo SP 15410-001, Brazil
P +55 1130852846
F +55 1130852846
ams-arquitetura@uol.com.br
Felix Beach House
Photos: © Nelson Kon

Claudi Aguiló Riu, Xavier Vendrell Sala
Avda. Içaria 180 6.º 1.ª
08005 Barcelona, Spain
P +34 932655486
F +34 932466829
car@bailen28.net
www.xaviervendrellstudio.com
Abelló Residence
Photos: © Jordi Miralles

Culti
Via Crocefisso 16
20122 Milan, Italy
P +39 036256946
F +39 036255729
www.culti.it
La Sommità
Photos: © Vega MG / Giulio Oriani

Delugan Meissl Associated Architects
Mittersteig 13/4
A-1040 Vienna, Austria
P +43 15853690
F +43 1585369011
www.deluganmeissl.at
Ray 1 House
Photos: © Hertha Hurnaus

Eduardo Souto de Moura
Rua do Aleixo 53 1.º A
4150-043 Porto, Portugal
P +351 226187547
F +351 226108092
souto.moura@mail.telepac.pt
Rua do Crasto House
Photos: © Duccio Malagamba

Emili Fox
105 Reservoir Street Surry Hills,
NSW 2010 Sydney, Australia
P +61 292112700
F +61 292112785
www.foxjohnston.com.au
House in Mosman
Photos: © Eric Sierins

Farnan Findlay Architects
6 Boronia Street, Redfern
NSW 2016 Sydney, Australia
P +61 293102516
F +61 293102517
www.farnanfindlay.com.au
Port Fairy House
Photos: © Brett Boardman

Federico Delrosso
Via Italia 38
13900 Biella, Italy
P +39 0152529090
F +39 0152438196
www.federicodelrosso.com
Lessona Terrace
Photos: © Matteo Piazza

Felipe Pich-Aguilera, Teresa Batlle
Ávila 138 4.º 1.ª
08018 Barcelona, Spain
P +34 933016457
F +34 934125223
www.picharchitects.com
Arquerons House
Photos: © Jordi Miralles

Graftworks Architecture+Design
1123 Broadway Suite 715
New York, NY 10010, USA
P +1 2123669675
F +1 2123669075
www.graftworks.net
Greenwich Roof Garden
Photos: © David Joseph

Jaime Guzmán, Fernando Ogarrio
Loma del Rey 10, Lomas de Vistahermosa
05100 Mexico DF, Mexico
P +52 5551001362
Citabria@mexis.com
Borja Residence
Photos: © Adam Butler

Jaime Sanahuja
Fernando el Católico 34 bajos
12005 Castellón, Spain
P +34 964724949
www.jaimesanahuja.com
Toran House
Photos: © Joan Roig

Katerina Tsigarida Architects
N. Votsi 3, 546 25 Limani,
Thessaloniki, Greece
P +30 2310526563
F +30 2310535918
www.tsigarida.gr
Holiday House
Photos: © E. Attali + G. Gerolympos

Lazzarini Pickering
Via Cola di Rienzo 28
00192 Rome, Italy
P +39 063210305
F +39 063216755
www.lazzarinipickering.com
Positano Villa
Photos: © Matteo Piazza

London Town PLC
7 Cowley Street
London SW1P 3NB, UK
P +44 2077993911
F +44 2077993912
www.londontownplc.co.uk
The Bridge
Photos: © Carlos Domínguez

Magín Ruiz de Albornoz
Pintor Vila Prades 19 bajos
46008 Valencia, Spain
P +34 963840664
F +34 963820413
www.maginslarquitectos.com
Beach Condos
Bétera House
Photos: © Joan Roig

MAP Arquitectos/Josep Lluís Mateo
Teodoro Roviralta 39
08022 Barcelona, Spain
P +34 932186358
F +34 932185292
www.mateo-maparchitect.com
Summer House
Photos: © Duccio Malagamba

Marcio Kogan Architects
Al. Tietê 505
São Paulo, SP 04616-001 Brazil
P +55 1130813522
F +55 1130633424
www.marciokogan.com.br
BR House
D'Andrea Henkin House
Quinta House
Photos: © Nelson Kon

Prima Design
Via del Campofiore 100
50136 Florence, Italy
P +39 055679715
F +39 0556550733
www.primadesign.it
Portman Residence
Photos: © Giorgio Baroni

Reinach Mendonça Arquitetos Associados
Rua Santonina 75 Conjunto 32 Vila Madalena
São Paulo, SP 05432-050 Brazil
P +55 1130321110
F +55 1130321110
www.rmaa.com.br
Glass House
Photos: © Nelson Kon

Ricardo Legorreta
Palacio de Versalles 285 A, Lomas Reforma
11020 Mexico DF, Mexico
P +52 552519698
F +52 555966162
relpublicas@lmsl.com.mx
Lourdes Residence
Photos: © Adam Butler

Riegler Riewe
Griesgasse 10
A-8020 Graz, Austria
P +43 316723253
F +43 3167232534
www.rieglerriewe.co.at
Penthouse T
Photos: © Paul Ott, Graz

Rios Clementi Hale Studios
6824 Melrose Avenue
Los Angeles, CA 90038 USA
P +1 3236349220
F +1 3236349221
www.rchstudios.com
Brentwood Pool & Terrace
Photos: © John Ellis

Safdie Rabines Architects
1101 Washington Place
San Diego, CA 92103 USA
P +1 6192976153
F +1 6192996072
www.safdierabines.com
Treehouse
Photos: © Adam Butler

Studio Architetti Associati di Andrea Lenzi e Stefano Bernardi
Corso Vendimini 34
47039 Savignano sul Rubicone
P +39 0541941680
F +39 0541941680
posta@saa.191.it
San Giuliano Mare Residence
Photos: © Vega MG/Gianni Basso

StudioMAS/Pierre Swanepoel
Unit 3, Courtyards on Oxford, 25 Oxford Rd,
Forest Town, Johannesburg 2193 South Africa
P +27 114862979
F +27 116465399
www.studiomas.co.za
Westcliff Estate
Photos: © StudioMAS/Mario & Dook

Thornsett Group PLC
126 Colindale Avenue
London, NW9 5HW UK
P +44 2089059899
F +44 2082006566
www.thornsettgroup.com
Marjory Street Terrace
Photos: © Carlos Domínguez

Wolfgang Ritsch Dipl. Ing.
Widagasse 11
A-6850 Dornbirn, Austria
P +43 557222482
F +43 557221421
www.ritsch-baukunst.at
Abrederis Residence
Photos: © Bruno Klomfar

© 2005 daab
cologne london new york

published and distributed worldwide by
daab gmbh
friesenstr. 50
d - 50670 köln

p + 49 - 221 - 94 10 740
f + 49 - 221 - 94 10 741

mail@daab-online.de
www.daab-online.de

publisher ralf daab
rdaab@daab-online.de

art director feyyaz
mail@feyyaz.com

editorial project by loft publications
© 2005 loft publications

editor antonio corcuera
layout cristina granero navarro
english translation pedro donoso
french translation pedro donoso
italian translation alessandro orsi
german translation anja llorella
copy editing alicia capel tatjer

printed in spain
anman gràfiques del vallès, spain
www.anman.com

isbn: 3-937718-25-7
d.l.: B-38462-05